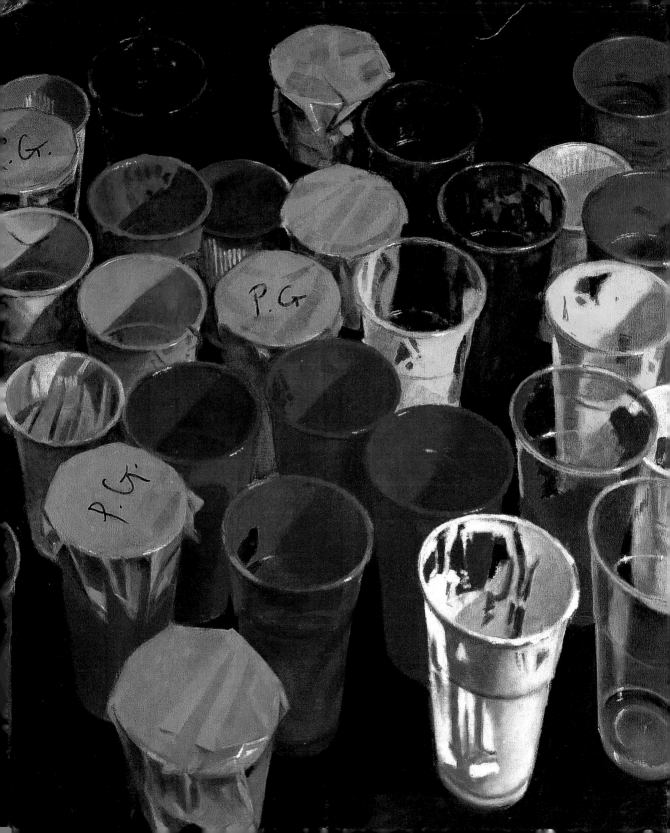

Sterling Publishing Co., Inc.
New York

AVA Publishing SA
Switzerland

Published by AVA Publishing SA
Rue du Bugnon 7
CH-1299 Crans-près-Céligny
Switzerland
Tel: +41 786 005 109
Email: enquiries@avabooks.ch

Distributed by Thames and Hudson
(ex-North America)
181a High Holborn
London WC1V 7QX
United Kingdom
Tel: +44 20 7845 5000
Fax: +44 20 7845 5050
Email: sales@thameshudson.co.uk
www.thamesandhudson.com

Distributed by Sterling Publishing Co., Inc.
in USA
387 Park Avenue South
New York, NY 10016-8810
Tel: +1 212 532 7160
Fax: +1 212 213 2495
www.sterlingpub.com

in Canada
Sterling Publishing
c/o Canadian Manda Group
One Atlantic Avenue, Suite 105
Toronto, Ontario M6K 3E7

English Language Support Office
AVA Publishing (UK) Ltd.
Tel: +44 1903 204 455
Email: enquiries@avabooks.co.uk

ISBN 2-88479-012-8

10 9 8 7 6 5 4 3 2 1

Design by Sally Chapman-Walker
Creative Director and co-ordination:
Kate Stephens

Production and separations by AVA Book Production Pte. Ltd., Singapore
Tel: +65 6334 8173
Fax: +65 6334 0752
Email: production@avabooks.com.sg

Detail on facing page:
'Still Life with Printing Inks'
by Jonathan Chapman

'Still Life in Oils

Theodora Philcox

Creative Painting

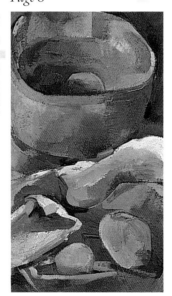
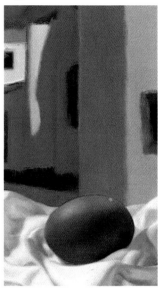

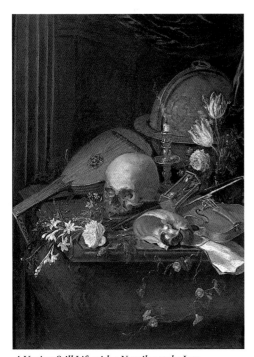

A Vanitas Still Life with a Nautilus and a Lute
by Matthys Naiveu (1647–1721)

Johnny van Haeften Gallery, London, UK / Bridgeman Art Library

In this 'vanitas', Naiveu incorporates a wealth of symbolism related to the transience of life including the skull, the hourglass, and the snuffed out candle, all painted with great realism.

When painting still life, the artist is truly in control. The selection of objects, their arrangement, the lighting and the background, can be infinitely reassessed and adjusted to create the desired mood and composition. In such a controlled environment, oil paint is the perfect companion to capture one's vision, providing absolute flexibility and the capacity to tackle the huge range of textures and colour modulations the subject dictates. In fact, the invention of oil paint was almost necessary for the development of still life as a painting genre.

Although prior to the Renaissance there had been small arrangements of objects within portraits, religious or allegorical paintings, still life was not a genre in its own right. With the development of science in the 15th century, artists sought to depict greater realism in their paintings. Although outwardly secular, there was still an undercurrent of religious interest in the study of nature, and this led Northern European artists to produce finely observed paintings of natural and everyday objects imbued with symbolic and religious meanings. Skulls were particularly common, along with snuffed out candles, mirrors, butterflies, broken pottery, wilting flowers, hourglasses or clocks, reminding their devout patrons of the vanity or transience of life. These 'vanitas', as they were called, became a defined sub-genre.

The invention of oil paint by the Flemish painter, Jan van Eyck, gave artists the possibility of rendering a tantalising range of surfaces, seducing artists into painting virtuoso studies. As the Dutch patrons became wealthier, they preferred to revel in the pleasures of life rather than being reminded of the inevitability of death. The subjects they commissioned thus changed to collections of artefacts brought back from travels abroad, luxurious possessions or exotic flowers. These allowed artists to render the silky weaves of ethnic carpets, glinting precious metals, the transparency of glass, and the delicacy of petals, feathers and furs, thereby showing off their skills with the exciting new medium.

By the 18th century still life paintings had lost some of their novelty. Mirrors, now cheaper and more widely available, began to replace them in domestic settings. Still life found itself relegated to a position considerably inferior to genres concerned with life itself. History painting (mythological and biblical scenes), which supposedly 'improved the mind and excited noble sentiments', took precedence along with portraiture for its obvious human, and potentially historic, interest. Still life sunk to insignificance along with animal painting and landscape.

It was not until the later 19th century that the impressionists breathed new life into the genre, lightening the palette and creating images that were both informal and personal. Exciting experimental works by Manet, Courbet and Cézanne, paved the way for the innovation of the 20th century. Through the structural experiments of cubism to autobiographical arrangements such as Diebenkorn's 'Still Life' and even three-dimensional works such as Dine's 'The Gate, Goodbye Vermont', the contemporary view of still life is incredibly varied and far from mundane.

The wide range of international contemporary artists featured here demonstrates the unlimited potential of the subject today. Sharing their experience, they talk through their personal approach to painting under the generic headings, 'Seeing', 'Thinking', and 'Acting', explaining their motivations, inspirations and techniques. Large reproductions of key paintings are supported by details, diagrams, or colour analyses; depending on the specific intent of the individual artist. The aim of this book is to capture the imagination of aspiring artists through a sensual and stimulating experience that will encourage them to discover their own unique creative voice.

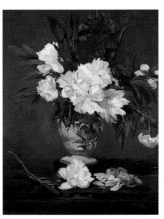

Vase of Peonies on a Small Pedestal
by Edouard Manet (1832–1883)

Musee d'Orsay, Paris, France
Lauros / Giraudon / Bridgeman Art Library

Manet inspired the informality of the impressionists. Although never fully joining their group, he experimented with a free, richly painterly brush, and created sensitive floral works full of energy and life.

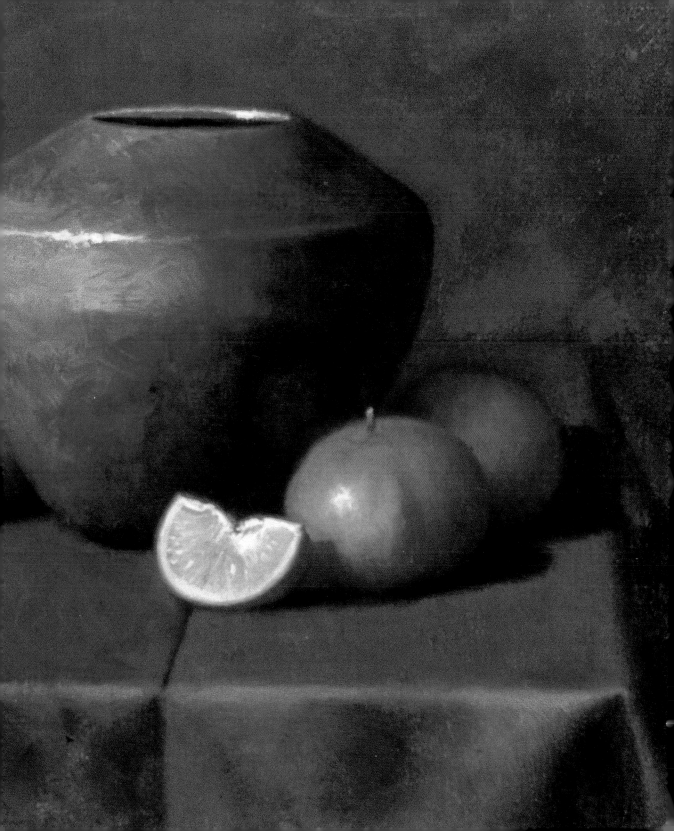

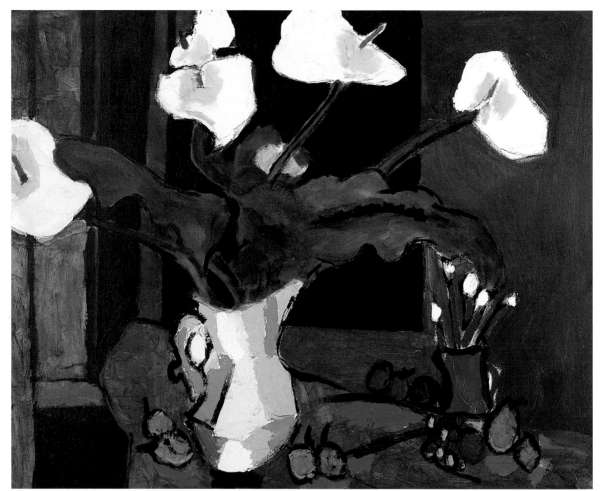

El Greco Flowers
by Philip Sutton

The glowing intensity
of the blue, red and
green, demarcated with
lines of black, suggests
the luminosity of
stained glass, providing
a rich foil for the pure
white flowers.

The use of colour has changed dramatically across the history of still life painting. Initially artists aimed to create the illusion of reality through absolutely accurate colour, made possible with the invention of oil paint. Some artists were so skilled that they were able to produce 'trompe-l'oeil' works where the eye is fooled into thinking the objects are three-dimensionally real rather than mere marks on a canvas.

Having got over the novelty of the illusionistic potential of oil, 18th-century artists moved on to explore its various other qualities. Chardin, for example, although equally concerned with realism, and a highly accomplished colourist, also explored its textural capabilities and developed a skill in rendering an extraordinary depth of tone, using subtle, harmonic palettes in keeping with his more domestic and humble subjects.

It was not until the later 19th century when the impressionists burst on to the scene that artists' approach to colour radically changed. Painting with a relaxed informality never before seen, artists such as Manet and Renoir applied their new ideas about colour, juxtaposing one against another, in broad dabs of paint. Colours blended in the viewer's eye rather than on the palette, and as a result, their work had a vibrant, shimmering, dynamic quality that remains popular over a century later. Peter Graham's work, featured in this section, owes a great deal to the impressionists' technique and exudes the 'joie de vivre' of his predecessors.

Moving into the 20th century with the foundations of modern art laid, artists were happy to continue and push forward bold experiments with colour. Matisse shocked the art world into describing him as a 'wild beast' in 1905 when his exuberant images with their clashing colours and rhythmic designs were shown at the Paris Salon d'Automne. These are echoed in the energetically expressive works of contemporary master, Philip Sutton RA, whose own rhythms and clean colours make his still lifes truly sing.

Previous page:
Turquoise and Tangerines
by Timothy Tyler

Although a simple composition, the fantastic contrast between the smooth turquoise pot and the textured orange tangerines makes a striking statement.

Peter Graham has developed an intimate understanding of the flower species he paints, but colour remains the main subject of all of his works. His technique is that of the impressionists and yet the results are firmly rooted in the 21st century.

Flowers for Valerie
30"x 30" (76cm x 76cm)

Flowers for Valerie

Whereas in landscape painting scale and perspective clearly throw up the differences between one feature and the next, on the more confined, intimate scale of flower painting, one flower can look exactly like the one next door. We are so used to seeing flowers that we tend to make assumptions from our imagination when we paint them. **I was surprised when I started to paint still lifes to find that I needed to reassess the way I looked.** *As I did, I was able to appreciate the subtle variations that make each bloom unique.*

A graduate of the celebrated Glasgow School of Art, Peter Graham has fast gained the reputation of being one of the United Kingdom's most gifted colourists and features regularly in key arts publications. Graham worked initially for the BBC as a film editor, but in 1986 turned to painting full time. Careful detail combined with fluid brushwork reminiscent of the liveliest of the impressionists, creates a dynamic exuberance that is all his own. Each year Graham spends the summer painting in the French Riviera. Scintillating beach scenes and harbours are key subjects in his oeuvre, but he is also renowned for his equally vibrant still lifes as can be seen here. In 2001 he was elected Member of The Royal Institute of Oil Painters, ROI. His work is held in private and corporate collections around the world.

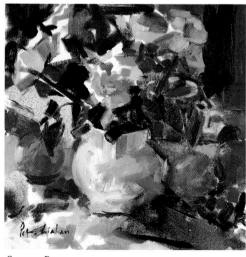

Summer Roses
12"x 12" (30cm x 30cm)

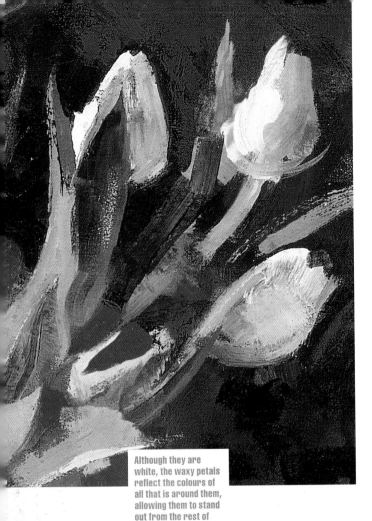

Although they are white, the waxy petals reflect the colours of all that is around them, allowing them to stand out from the rest of the composition and yet be fully united with it at the same time.

Graham's key colours include:
Cobalt Blue
Cobalt Turquoise
Winsor Violet
Cadmium Red
Cadmium Green
Prussian Green
Rose Madder Genuine
Raw Sienna
Raw Umber
Lemon Yellow Hue
Cadmium Yellow

seeing

*This painting was inspired by an exhibition of paintings by **William Nicholson** (1872–1949) at Kettles Yard in Cambridge, and in particular a painting of white tulips. The idea of painting white tulips had been in the back of my mind for some years and eventually spurred on by this work, I decided to try a still life with these flowers as the focus.*

I create my still life paintings with only a rough idea of composition in my head. I often move the objects around on a daily basis as I paint them, and only introduce the fresh flowers once I am fully satisfied with the arrangement. Here, atmosphere through use of Madders and Siennas give this painting the mood I wanted. An intimate moment. Depth within still life is an exciting part of the subject. Describing just a few feet into the canvas gives rise to dealing with very subtle relationships. **I have used glazes to enrich the dark tones and shadows, and also to bring a transparent quality to the jug.**

Graham uses the loose, broken brushwork of the impressionists, often allowing his vibrant colours to blend in the eye, rendering an exciting dynamic surface.

In all my work I am interested in light and the way it falls, so I always work from life. I have developed a style that is impulsive and spontaneous. **Within a very short period of time I build the image with rapid marks, dabs of colour, over-painting, scraping paint back, and then adding more.** If it doesn't work I will start all over again. I know when I have got it right. I use a white canvas so that the light can reflect through the paint to make it more luminous. Although I am spontaneous in my approach, I do draw out the general arrangement of shapes in a very light colour. This is helpful since if I make a mistake it can easily be corrected. When I introduce colour I go right in with bold, vibrant colours although these are diluted in the early stages with distilled turpentine. I work fat over lean.

I am not too concerned with the discipline of style, and often my finished pictures will have some very roughly treated areas, perhaps barely painted at all, which contrast with more detailed objects and patterns, layered with glazes or thick impasto. This method allows me to lead the viewer's eye around the canvas from one focal point to the next, so that they become involved with the subject – and that's very important! For me, also, it is this freedom on the canvas that brings the rewards of being able to capture my feelings.

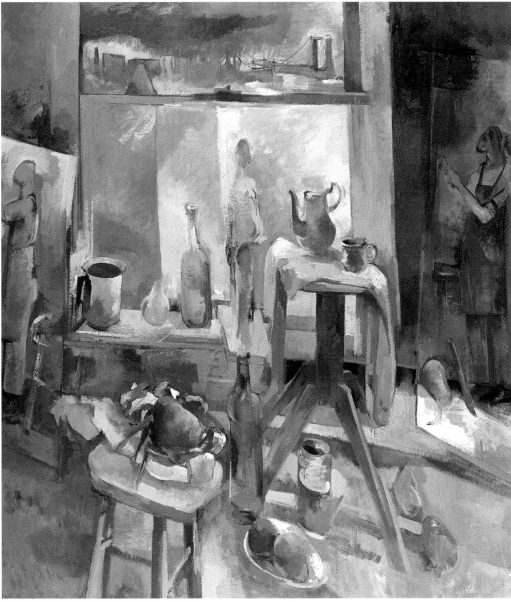

This is a very complex still life, exploring the play of light over a multitude of objects. Martha Hayden keeps her options open as she works, allowing the painting to evolve in terms of colour and abstract forms.

Still Life with Many Objects
52"x 46" (132cm x 117cm)

Still Life with Many Objects

I do not work from A to B to C. In my opinion, art cannot be made in that way. Painting then becomes a kind of craft. This painting is an outgrowth of a series of works about windows, about outside and inside, about seeing near and far together. It is a study in formalism. **There is no narrative to hold the objects together; their relationships are purely abstract.**

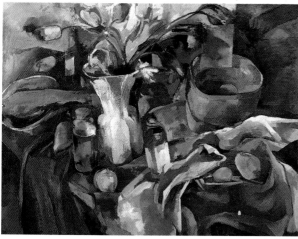

Red Still Life
36"x 46" (91cm x 117cm)

Martha Hayden is a graduate of the school of the Art Institute of Chicago and was awarded a fellowship from the Art Institute for study and travel in Europe. She studied at the Schüle des Sehens in Salzburg, Austria with the expressionist painter Oskar Kokoschka and won the Schüle's top award for the work she did there.

Her work has been widely exhibited. She has participated in shows at the Art Institute and the Milwaukee Museum of Art, The National Academy Museum in New York City, The Wustum Museum in Racine, Wisconsin, the Butler Institute of American Art in Youngstown Ohio, the El Paso (TX) Art Museum, and many others.

She has had numerous one person shows including exhibitions at Reggio Gallery in New York City, The West Bend (WI) Museum, Beloit College, The Wustum Museum (Racine), The Chicago Public Library, and Bradley Galleries in Milwaukee.

Her mural in the Beloit Municipal Building (6ft x 92ft) is Wisconsin's largest landscape painting.

She is included in many public collections, including the Museo do Arte Moderno, São Paulo, Brazil, and The Smithsonian. Corporate collections include those of Amoco, GTE, Ameritech, and Frito-Lay.

Martha Hayden's work has won more than 50 awards and has been exhibited in over 350 regional and national museum and gallery exhibitions.

There are many compositions within the larger image – compositions of vertical and horizontal planes, the movement of large planes, etc. It is a complex painting with elements that function on many levels.

I don't paint by plan; I do set up still lifes, often the same objects over and over, but in different situations. I like a separation between objects and a play of light. **The light needn't be and isn't constant; it comes and goes and I use what I like best.** *This painting has an afternoon light, once that was established, I worked on it only in the afternoon. When I see a complex of colours and shapes that I enjoy, I paint that. I am familiar with the objects, I have used them all many times, but I try to see them with an 'innocent eye' as if I've never seen them before. In a new configuration they acquire a different life.*

In this complicated painting, I have many elements functioning on multiple levels. **My diagrams show arrangements and hierarchies of vertical and horizontal planes, of diagonals and pyramidal shapes and of movements through space and air.** *The painting is composed in more than one way. These overlaps reinforce and also contradict each other. Seeing, or life, is that way.*

Our eye is led up and out through the window where we find a landscape, essentially a painting within a painting.

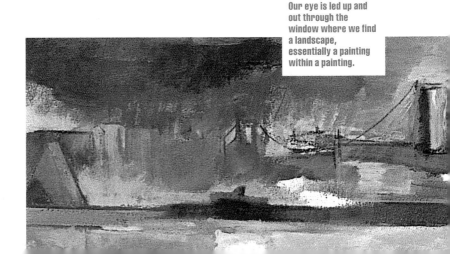

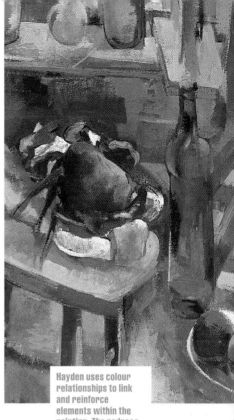

The start is nothing like the finish, and everything is kept in flux. What appeals to me at the start may not be what I see in the end. In the beginning I saw the little sculpture and the blue bottle as part of a blue streak vertically bisecting a yellow painting. But, as I worked, that became simplistic and I found better ideas. I always think in terms of creating space. Space is created through relationships of colours and the planes that bear them. The eye will notice shapes and colours that are similar. Thus the bottle and little figure can be seen together, the distance between them (marked out by the horizontal yellow base) sensed, while concurrently, the alignment of the two forms emphasises the surface of the picture itself.

We see the red of the crab and sense the red of the apple far below and the cup far above. We can see them both together and apart. *We also see the reddish spot in the blue below and to the left of the crab; not only does it enliven the blue by an addition of a warmed colour of the same value, it anchors and reinforces the position of the crab. There are layers of tensions like these noticed and introduced throughout the process of painting. By seeing from one shape and colour to another, a sense of space is gradually built up. The painting, originally yellow, becomes blue, made bluer by its complement of rich orange browns keyed to the values of the blues. The reds are both a part of the brown complex, and accents. Greens are also part of the blue complex, and when they become sharp, are lesser accents, helping to make the red redder.*

We sense ourselves outside the picture; we are reflected in the mirrors. The eye moves through and up the picture, and again outside through the window. The landscape at the top is infinite space and also a little painting within a painting.

Hayden uses colour relationships to link and reinforce elements within the painting. The redness of the crab is picked up in that of the apple, creating subconscious dynamics within the composition.

" I don't paint things; I paint relationships, using them to create depth on a flat surface.

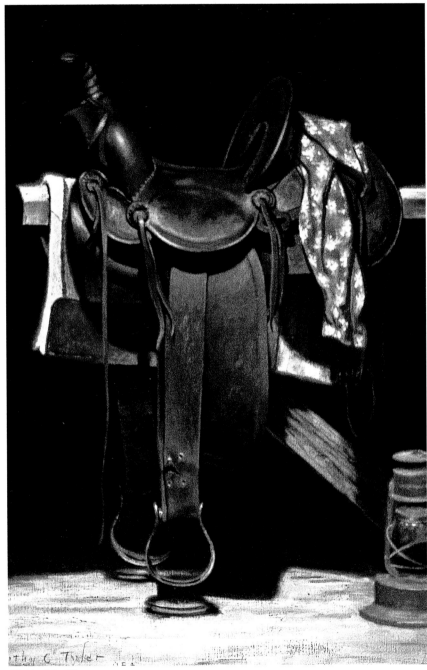

Timothy Tyler aims to capture colours precisely. His technique also allows the viewer to fully appreciate the textures of the objects he paints. The glossy leather, subtly rich colour and sweeping curves of the saddle appeal to the senses, making its viewing an almost tactile experience.

Highback Saddle
30"x 24" (76cm x 61cm)

Highback Saddle

I had started borrowing antique saddles from collectors and had an idea in my head for painting a group of them. I started looking for antique saddles and antiques, and put the arrangement together. After doing the painting 'The Saddles Now Silent', I met other people who had collectable saddles and tack, and found this rather interesting one. I looked over dozens and dozens of saddles. Sometimes the ones collectors love because of the rarity or maker were not interesting to me. **I was looking for the gloss of the aged leather, shape and style only. I am very interested in abstract design!** *So I simply found this great one and painted it next.*

Timothy Tyler has been an artist all his life. He was undertaking commissions for oil paintings at age 14. Two years later, he was exhibiting in a gallery and the college he attended purchased a painting in his freshman year. Now, after 28 years at the easel, his paintings have been dispersed worldwide through gallery sales. Four 'Fortune 500' corporations own his paintings.

Tyler's studio has 175 square feet of north light and three sky lights. There he carefully studies the delicacies of fresh orchids and roses or enlarges field sketches previously made 'en plein air'. For these references, he travels widely. His sons take turns 'going with Dad' to places like Teton National Park, the Redwoods, or the Grand Canyon.

There is a wonderful sense of light in his work. Whether painting figures, still lifes, or landscapes, his aim is to capture precisely the colours, edges, and shapes. His work has been featured in a number of American journals, and in 1993 he gained full signature membership of the Oil Painters of America.

The Saddles Now Silent
42"x 72" (107cm x 183cm)

turner

My business is
to paint not
what I know,
but what I see.

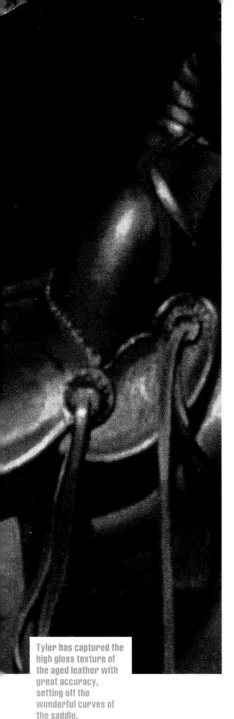

Tyler has captured the high gloss texture of the aged leather with great accuracy, setting off the wonderful curves of the saddle.

I paint 'sight-size' from life, just like J S Sargent did from his Tite Street studio in London. Essentially this means positioning your canvas a specific distance away from the subject, and then stepping back from the canvas until both the work and the subject are visually the same size. In doing this, **the necessary distance between the subject and the artist allows the artist to see the subject in one glance without having to change his or her point of view.** This is perhaps more obvious when painting figures, which I do a lot, where the distances are relatively great. Normally, in this case, the artist would have to lower his eyes to take in the feet, but it holds true for any subject.

thinking

I read the still life set-up from about 20 feet and both paint and make my decisions from there. I spent a long time setting this composition up. Much of it was done in the round, like stage design – literally moving objects about, considering the way light looks on the many surfaces. **While I'm designing the set-up I am always thinking about negative shapes, light against dark, cool against warm, soft edge near hard, etc.** I hate unclear intersections and move things about to minimise these. If any shapes appear redundant or boring, I get rid of them. So when I go to paint my only concern is painting what I see, since all of the other issues have been resolved in developing the set-up.

 I aim to capture the colour precisely, as it is viewed from life. I consider its temperature, hue, intensity, and tone; constantly looking from the painting to the set-up to check its accuracy. If it's not right, I will always adjust the initial colour put on the canvas even if it is only slightly 'off'. My palette varies according to the subject. I use a wide mix of brushes, from sables to bristles, and I will use small detail brushes and large brushes (no.14 filberts) on the same painting. Sargent told his students that an artist should use as big a brush as possible – he said you can tell if you have the right brush if it feels just a little too big. I think with paints and brushes one should have a wide range of options at your disposal.

*I draw the image in with thin paint, placing the objects on the canvas first generally, and later more precisely. **The closer I get with my initial sepia drawing the less difficulty I have later when I start with the colour.** After less than half an hour of the initial drawing I begin to put in accurate colours, as close to the colour I see on the subject as possible. It is easiest to start at the spot where I can read the colour most clearly. Bright, intense colours are usually the most obvious, and then the greys or neutrals are easier to nail down. Reading what tone and temperature these subtle greys are is important but tricky.*

*Once I have determined a colour to my satisfaction I mix up a little more than enough of that colour and place it on the work fairly thickly. I will, at this point, be concerned about edges and reflected light from the adjacent objects. I strive for my painting to look like the subject matter. I don't paint what I think I know or 'my favourite colours' or anything other than what I see. **There are lots of odd things going on in the real things I'm painting. If I capture these well my work has credibility!** Like many other artists, I alter the way I work according to the demands of a particular painting. My methods are similar to how most artists have worked for centuries, it is certainly not a new way of painting.*

The soft folds of the fabric create a strong contrast to the hard sculpted edges of the leather. Such contrasts are crucial to Tyler as he sets up his still lifes.

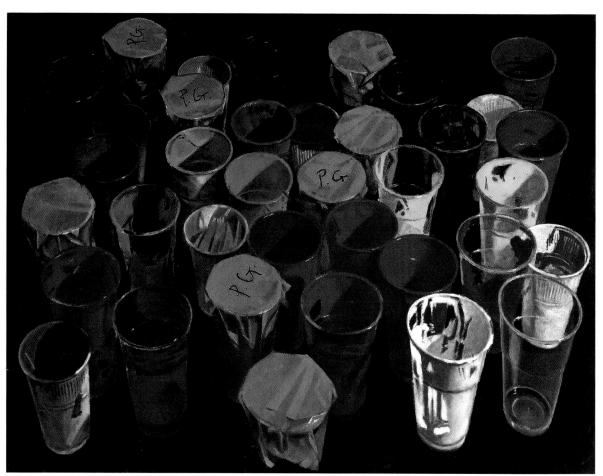

Still Life with Printing Inks
36"x 48" (92cm x 123cm)

Although uniform in their basic shape, these beakers have their own identity through the residue of colour from the printing inks they contain and have contained. The colours are arranged so that they get progressively cooler as they move back into the picture space.

Still Life with Printing Inks
 The genre of still life allows me to work from something in front of me and maintain great control over the formal characteristics of a painting. **I enjoy the process of looking hard at a group of objects and then translating my perception of them into a two-dimensional illusionary equivalent.** *I try to represent the material 'reality' of a set-up and the material reality of paint on canvas.*

 The choice of objects and their arrangement is to a greater or lesser extent determined by the combination of three factors. Firstly, an object may have a personal significance for me, and painting it allows me to reflect upon that narrative. Secondly, an arrangement may have formal qualities, its colours or patterning for example, that provide me with an interesting representational problem to solve. Thirdly, a set-up may allow me to enter a visual dialogue with an aspect of a historic or contemporary painting which may or may not be a still life and might well be non-representational.

Born in 1965, Jonathan Chapman was trained as a painter at Leicester Polytechnic. Following a period working as an exhibition organiser at the Richard Demarco Gallery in Edinburgh, he gained an MPhil in Public Art and Design from Duncan of Jordanstone College of Art in Dundee. He exhibits widely in England and Scotland and currently lectures in painting at University College Northampton.

Still Life with Complicated Reds
24"x 24" (62cm x 62cm)

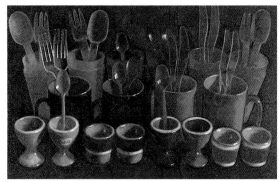

In this arrangement the 'starts' of a number of previous still lifes were lined up like a family photograph with the greens on the left and the reds to the right.

Still Life with Rows of Beakers, Mugs and Egg Cups
24"x 36" (60cm x 90cm)

seeing

I saw these transparent beakers, full of mixed up screen printing colour, in the printmaking area of the art college at which I teach. **I enjoyed the way in which their standardised forms were customised by the pigment they contained and the painterly marks unselfconsciously created by the mixer.** Further variety was provided by the occasionally taped and initialled lids and a number of smaller white beakers.

The residues of pigment, and marks left by the mixer, individualise each of the beakers. The combination of the opaque and transparent form interesting paths for the eye, blocking off and leading through, eventually to the back of the painting.

Although I may sketch down ideas for paintings in a sketchbook or on the back of an envelope, preliminary compositional studies are largely replaced by a process of placing, replacing and adjusting groups of objects and backcloths. **The internal logic for this painting was simply that the transparent beakers containing warm colours would be arranged at the front and then they would move through oranges, yellows and greens towards the cool blue and grey ones to the back.** This was balanced by the inclusion of smaller white beakers running contrary to this and allowing red to be glimpsed in the background and cool purple in the foreground.

For me, the positioning and balancing of the coloured beakers within the actual still life set-up is analogous to an abstract painter carefully arranging areas of colour within the pictorial space of a canvas. Therefore this still life enabled me to organise and distribute coloured shapes in a formal abstract manner and become involved in the realist agendas of material depiction and spatial illusion. In order that the colour was as vivid as possible and that the three-dimensionality of the beakers was clearly evident, I placed them on a black velvet cloth and lit them from the side with a daylight bulb.

The composition was initially drawn in chalk on a mid-tone ground. I was particularly interested in examining the way the ellipses alter and distort at the edges of the picture and from foreground to background. The whole painting was then blocked in using oil colour diluted with turpentine. I used a fairly broad palette, and, unusually for me, **I used a Payne's Grey glaze to finally model the beakers and bring a unity to the strong, potentially disparate colours.**

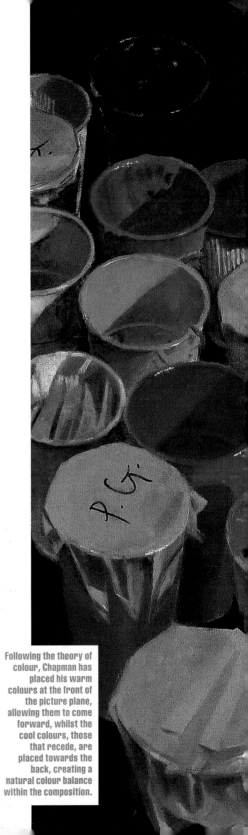

Following the theory of colour, Chapman has placed his warm colours at the front of the picture plane, allowing them to come forward, whilst the cool colours, those that recede, are placed towards the back, creating a natural colour balance within the composition.

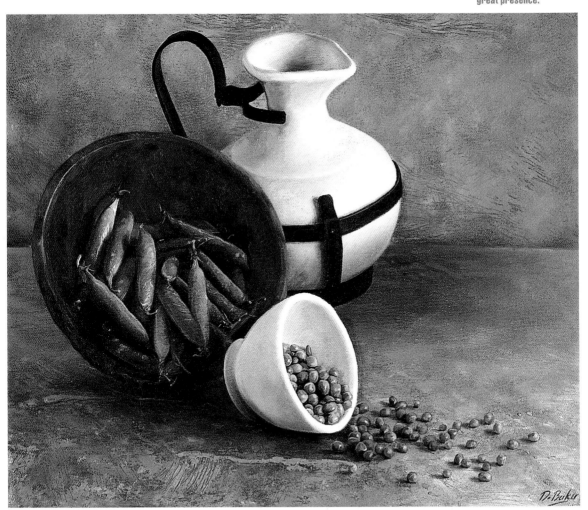

Still Life with Peas
12"x 16" (30cm x 41cm)

Still Life with Peas

Working as a still life painter I am constantly observing and studying inanimate objects, shape, form and the play of light. My paintings owe a great deal to the classical masters of still life. My goal is to infuse the classical principles/traditions into contemporary and antique subjects.

Graduating from Bradford Art College in the summer of 1998, Darren Baker has already established himself as an artist within the industry. Upon leaving college he exhibited successfully in London and was selected to exhibit in a millennium show in New York. In the same year he was also appointed official artist of The Professional Footballer's Association. He has worked for clubs and companies including Leeds United, Glasgow Celtic, Bradford City, and Granada TV, and has produced images for such luminaries as Teddy Sheringham, Prince Naseem Hamed, Frankie Detorri and Lestyn Harris.

Baker's paintings have been exhibited in Harrogate, Manchester, Cheltenham, Chichester, Birmingham, Middlesborough, Dumfries, the Royal Academy and Mall Galleries, London, as well as in his native West Yorkshire. He also had Year 2000 Summer Shows in Liverpool and New York. His work is on permanent display in Saltaire, near the world famous David Hockney Gallery.

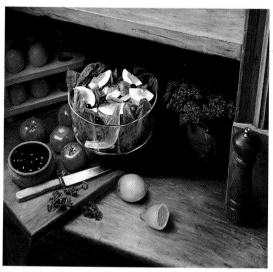

Tuna Salad
20"x 20" (51cm x 51cm)

Still life painting is essentially about 'seeing', to paint the subject you have to understand it – almost religiously. **I will smell, feel and taste objects to convey their essence and tension on a flat surface.** *'Still life with Peas' was part inspired by a still life show in London and observing details in Velázquez's 'Water Seller of Seville', especially the beautifully observed earthenware. The painting also sprang from seeing my mother picking and washing peas, escaping from her hands and then trickling all over the table. I wanted an arrangement that projected various shapes, tones and textures.*

I composed the objects tightly together, squeezing them into the canvas' dimensions – accentuating the power of the objects. Before setting up I produced an initial tonal and compositional drawing to guide me.

Having watched his mother spill some peas and seeing them trickle all over the table, Baker wanted to capture the random composition as they lightly scattered across the cloth.

Preliminary steps in producing the painting involve devising a strategy – what palette, lighting, support, methods? My thumbnail sketches give me a basic picture of these core elements. **I decided a cool palette would work well with the pea subject, using my cellar as a backdrop, with its textural walls and floor.** *I used a natural light source and small spotlight to heighten forms.*

For oil paintings I either employ wood panels or fine canvas. For this painting I selected canvas for its responsiveness and support of impasto, which I intended to use in the piece.

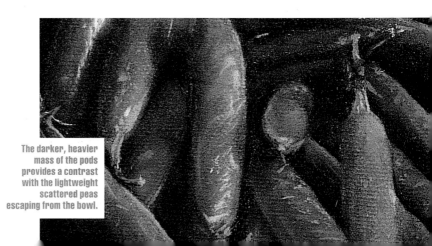

The darker, heavier mass of the pods provides a contrast with the lightweight scattered peas escaping from the bowl.

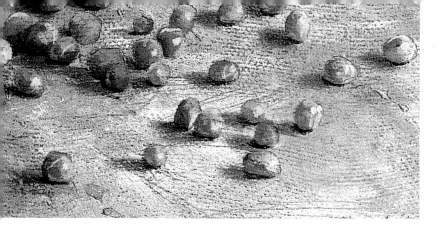

Baker's cool palette:
Cobalt Blue
Flesh Tint
Naples Yellow
Sap Green
Transparent Brown
Raw Sienna

Underpainting palette:
Burnt Sienna
Burnt Umber
Ivory Black

acting

The painting was conceived and completed from a whole host of references. Initially I began by making a detailed pencil drawing that I transferred to the canvas, using pin-pricked paper and soft graphite. I also made a series of charcoal studies exploring arrangement, light, and surface details.

Under-painting is the core of my work, and a great deal of time is spent on this stage of the painting. Here I used three colours, Burnt Sienna, Burnt Umber, and Ivory Black, forming a gradual tonal key on the palette. The under-painting is a loosely detailed version of the picture. Once this painting is dry I paint the principal elements by literally blocking in the local colour in dark tones. This layer allows the under-painting to resonate, creating depth.

I paint using thin glazes, laying down base colours, allowing them to dry before overlaying films of colours to establish form and detail. I then build up to thickly applied highlights that throw the objects forward. **As I paint from life I touch the set-up to understand the structure – this informs my painting by showing me how I should capture a certain detail.**

The backdrop was almost painted abstract. I loosely brushed in a suggestion of the surface. Once dry I scratched at the surface, applying paint with a palette knife to convey the palest texture. Finally I overlaid glazes to describe shadows, marks and details.

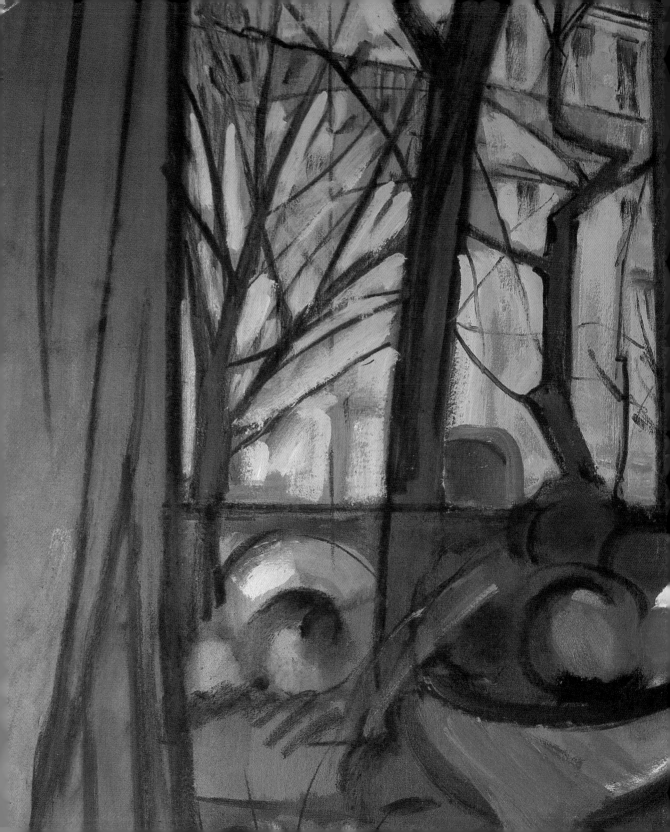

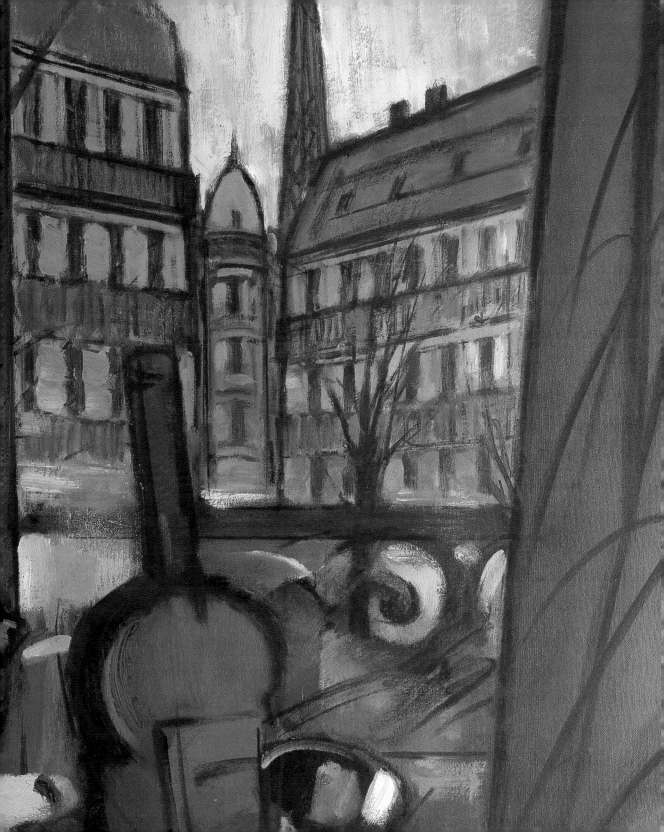

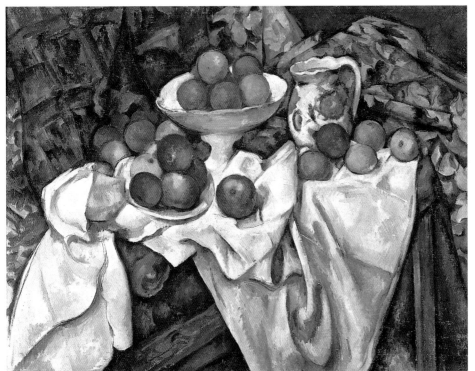

Apples and Oranges, 1895–1900
by Paul Cézanne (1839–1906)

Musee d'Orsay, Paris, France
Lauros / Giraudon / Bridgeman Art Library

In Arthur Easton's compositional sketch we can clearly see the traditional pyramidal compositional structure, used by the 17th-and 18th-century masters.

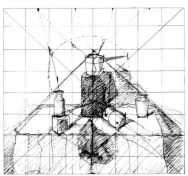

Whereas in landscape painting the artist might have to 'rearrange' elements or even invent some to create the best possible composition, in still life, the artist can control every aspect of the subject he or she paints. The selection of objects, their arrangement, the lighting, and the background can be reorganised at will for creative effect. Enriquillo Rodríguez Amiama undergoes an interesting and lengthy preparatory process to develop the composition he wishes to work with. He first selects the fruits and vegetables that will feature in his work, photographs them in a variety of arrangements, and then seeks out interesting 'backgrounds' by searching the web for abstract paintings, colour fields, etc. He finally brings these together by cutting and pasting photographs and computer print-outs, and then painting the collaged result. Other artists simply move the objects around within the set-up, perhaps making preliminary sketches as they go to focus on how the eye will be led around the image. Arthur Easton, for example sketches out the geometric matrix to which his still life will conform.

Still lifes dating from the 17th and 18th centuries tend to be composed along traditional lines using either a pyramidal structure or the Golden Section, the system whereby the composition is divided into broad thirds. These 'rules' lost their currency with the impressionists, inspired by exciting asymmetrical art works flooding in from Japan.

Freed from convention, artists became ever more exploratory. Cézanne, frustrated by the impressionists' obsession with capturing the fleeting effects of light, which sometimes resulted in insubstantial renditions of objects, wanted instead to create a sensation of solidity. He was thus more concerned with the structural elements of nature, viewing all objects in terms of their underlying geometric form. Everything, he believed, should be conceived in terms of the cubes, cones and spheres that underlay their outward appearance. Going beyond this, he attempted a fully three-dimensional realisation of form by deliberately tilting dishes, balancing them on piles of coins, so that he could see further into their depth and more of what they contained. Similarly, his apples look almost overly round, a result of looking at, and then capturing, what he could see to the extreme right and left, fully utilising the powers of human binocular vision. I have often wondered if he had a slight defect of vision, a squint, perhaps, that made him actually see that way. Whether or not this was the case, it paved the way for one of the most dramatic developments in the history of art – cubism.

Still life was the staple subject matter of cubist artists Picasso, Braque, and Gris. Spending, as they did, many hours in café-bars, their still lifes were ready set up with carafes, glasses, fruit, newspapers and musical instruments, right there in front of them. Analysing form in limited palettes, they went further than Cézanne to explore the notion of simultaneous vision, (seeing their objects through 360°), and recording all that this told them about their subject. What had been a traditional subject using linear perspective, was fragmented into multiple planes, reflecting the multi-faceted human perspective in the face of rapid change in the early years of a new century. The style has stayed with us. Vladimir Ilibayev, working with similar subject matter, also constructs his compositions with interpenetrating planes, drawing the viewer back and forth into the picture space, in a rich medley of colour.

Previous page: **Still Life with Fruit** *by Vladimir Ilibayev*
Borrowing concepts from the cubists, Ilibayev constructs images with distorted perspective and interpenetrating planes, moving the viewer's eye around and deeper into the picture space.

Below: **Still Life with Waterbottle, Bottle and Fruit Dish, 1915** *by Juan Gris (1887–1927)*
Private Collection / Bridgeman Art Library DACS London 2002
Spanish artist, Juan Gris was a follower of Picasso and Braque, and like them painted carefully constructed still lifes built up of interpenetrating planes, bereft of linear perspective. Shattering artistic conventions that had been held for centuries, this approach marked a turning point in the history of art.

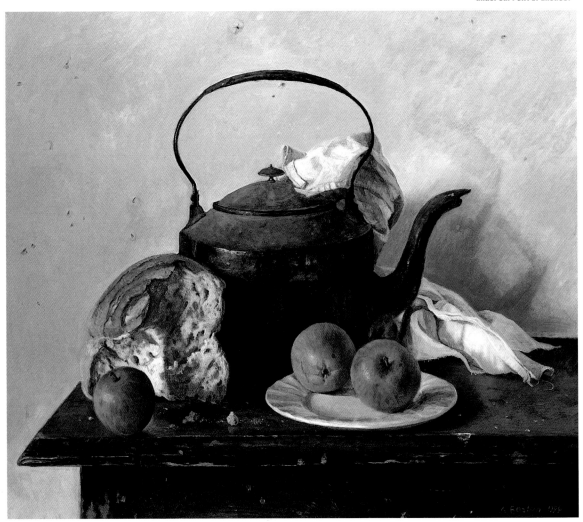

Still Life with Kettle, Apples and Bread
18"x 24" (46cm x 61cm)

> ## Still Life with Kettle, Apples and Bread
> *My still life work is strictly representational and the objects are arranged in a formal way. One of my aims when I compose a painting is to create a feeling of ambiguity and I select and juxtapose objects towards this end.* **Although my compositions are balanced, I also attempt to create a slight imbalance** *– a feeling of instability, of unease, of something about to happen, or something not quite resolved or completely understood.*

Arthur Easton was born in Horley, Surrey in 1939. He is best known for his meticulously executed still life paintings. After studying painting and printmaking at Reigate School of Art he began teaching both at the School and other adult education centres in addition to working as an art therapist in psychiatric hospitals.

Easton was elected a member of the Royal Institute of Oil Painters in 1979, and in 1991 was awarded the Institute's Stanley Grimm Prize, as a result of being voted the most popular painter by visitors. His work has been exhibited regularly at the Royal Academy and can be found in the collections of Princess Michael of Kent, the Museum of British Labour, the American Institute of Strategic Studies, and private collectors in America, Australia and Iran.

Still Life with Fern
36"x 30" (91cm x 76cm)

Self Portrait and Child's Chamber Pot
36"x 30" (91cm x 76cm)

seeing

Over the years I have accumulated a collection of objects; most of them are quite unremarkable, in fact they are the kind of things most people would throw away. I tend to favour objects that have a neutrality, not brightly coloured or intrinsically dominant. **The objects in this painting were chosen because of their different textural surfaces, rough against smooth,** *but I was also interested in the tonal values.*

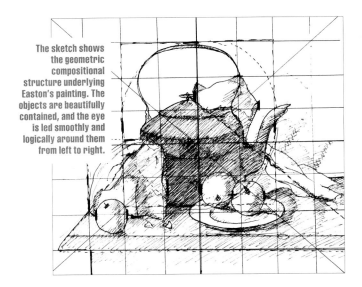

The sketch shows the geometric compositional structure underlying Easton's painting. The objects are beautifully contained, and the eye is led smoothly and logically around them from left to right.

thinking

The composition is loosely based on a triangle. On the left, the eye is taken upwards along the edge of the table, then along the edge of the bread's crust to the handle on the kettle. On the right-hand side the eye is directed to the kettle handle via the line of material; the base of the triangle is the front edge of the table. A vertical can be taken down from the kettle handle to the left-hand edge of the plate – this is the centre of the triangle. Other lines can be taken through, subdividing the composition into more or less equal parts, giving the whole a stability. I say more or less because, as I have suggested above, I feel that a slight feeling of instability is essential.

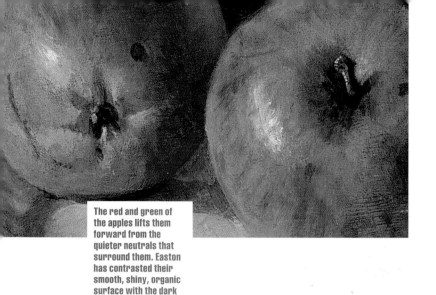

The red and green of the apples lifts them forward from the quieter neutrals that surround them. Easton has contrasted their smooth, shiny, organic surface with the dark metal of the kettle.

acting

The different textures were achieved by the technique of scumbling – lightly dragging paint over darker dry layers of paint. Subtle colour nuances were achieved in this way also. I use very little medium, just a little turpentine for the initial blocking in.

The combination of the rough crust, and soft textured bread creates a strong contrast with the smooth kettle and apples.

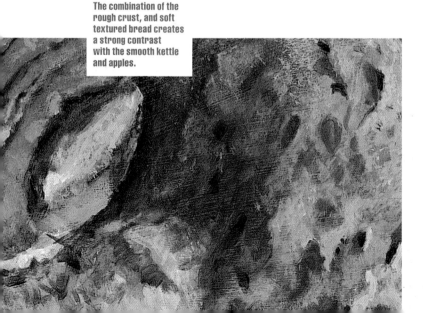

'SCUMBLING' TECHNIQUE

Easton uses scumbling to create texture. It involves dragging a lightly loaded brush over another dry colour, either light over dark, or dark over light. It adheres in places, and not in others, leaving a lively broken surface, ideal for creating natural textures or aged and weathered surfaces.

Gorgeous natural light is the subject of this painting as much as the objects within it. Varying intensities of light and shadow form distinct contrasts and define the overall structure of the painting, producing a composition that is full of atmosphere.

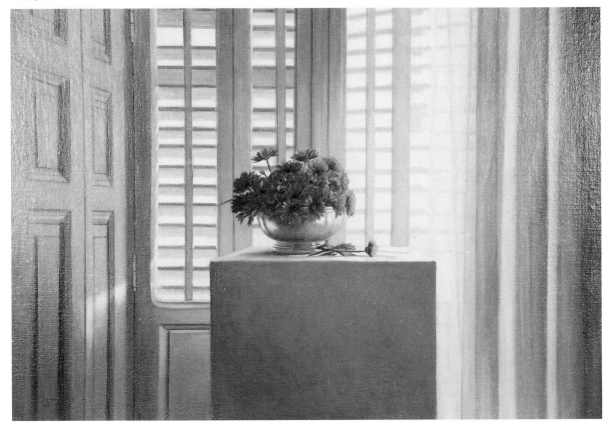

A Morning in Spring
30"x 41" (75cm x 105cm)

"

A Morning in Spring
I left home heading for the studio. It was a fresh morning,
with all the signs of spring arriving: birds flying from branch to
branch, and the first leaves and flowers appearing on the trees.
This encouraged me to walk into the first flower shop I came across.

Laurel Branch
After considering various factors such as the time of day, whether or
not it was sunny or cloudy, and after trying out different objects in the
composition, I selected objects made of different metals: silver and
brass. Although a simple composition, I thought it was quite elegant.
I added the plums for their colour, in this way giving the composition
a balance of colour tones. To the right, and in front of the table is the
window, which I opened wide, letting through that beam of light
which illuminates part of the painting. The plums, which are in the
silver bowl, are in the darker part, but the plum on the left receives
light directly from the window, as does the brass pail.

Using the Renaissance method, Juana Cañas creates her paintings based on a system of glazes as used by the old masters. Her paintings demonstrate strong compositional skills full of vibrant colour. During the 1970s, her work was praised and awarded in the United States by cultural institutions, and in the autumn of 2000 her work was selected for the cover of Symposium, a Washington journal in Modern Literatures.

Spain is where her work acquired its present-day personality, gained during years of studying realism and impressionism in Madrid, coupled with visits to Paris, London, and Washington. Her work includes drawings, oils and prints, whilst her still life paintings have been described in the press as those 'which capture the finest Spanish tradition of the genre'.

She currently produces her work at studios in Madrid and Toledo, combining smooth and delicate brush strokes with beautiful colour tones. Cañas exhibits regularly in London, and her paintings are held in the Spanish National Heritage Collection as well as many private collections.

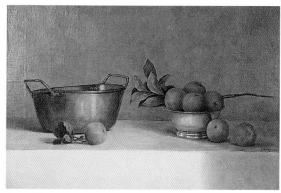

Laurel Branch
23"x 30" (58cm x 75cm)

The composition was arranged so that sunlight would pierce the picture space in controlled, intense bursts.

I caught sight of an earthenware bowl full of beautiful orange flowers, so I bought a handful, and by the time I reached the studio I already knew what my composition would be. **It was a gorgeous day and the sun shone right through the balcony window where I had planned to set up my composition. But there was too much light, and what I had in mind was to use backlighting.** *So I closed the shutters, leaving them ajar, allowing a ray of sunshine through. I then prepared the flowers.*

The backlighting is the basis of this work. **With the shutters closed and the lattice window half open, light came through the interior door of the balcony, with an intense ray of sunlight in the lower part of the doors.** *As a result, there were different intensities of light. The front of the plinth, which I used as a table in this composition, is completely in shadow, while the horizontal side is illuminated by the light that penetrates through the lattice window. The silver bowl, and the flowers themselves are backlit, with light falling from the right on some of the flowers. To the right of the picture we can see part of the transparent curtains with the drapes in the foreground. There is an array of contrasts, giving the whole ensemble the atmosphere which envelopes the whole painting.*

A limited palette: Ivory Black and White, plus French Ultramarine Crimson Alizarine Cadmium Red Cadmium Lemon Yellow Ochre Burnt Sienna

THE GRISAILLE TECHNIQUE

1 Once the canvas has been pasted to the board with glue and it is dry, stucco can be applied.

2 The canvas is finished with the final coat of diluted glue and pigment.

3 Drawing directly on to the canvas.

4 Beginning the grisaille.

5 The first coat of grisaille covers the whole of the canvas.

6 The second coat of grisaille intensifies the light.

7 The first coat of colour in translucent glaze.

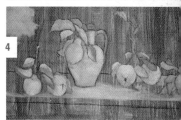

acting

I begin my paintings by pasting the canvas on to the board with natural glues. Then I apply a fine or thick layer of stucco, depending on the theme. I usually finish with a fine layer of diluted glue with the addition of a little pigment. The purpose of this latter step is to reduce, somewhat, the absorbency of the stucco. I prefer yellow-ochre pigments with a little Red Iron Oxide.

Once the canvas is ready, I start drawing my composition directly, without worrying too much about the details of the drawing. **The technique I use is that of the Renaissance masters, and is known as grisaille. It first requires a monochrome base of different tones of whites and greys.** *This helps to define the drawing and distribute the light and shadows around the composition.*

I like to intensify the light in the painting with a lot of thick white paint on the objects, or in the bright backgrounds. During this stage, while painting the grisaille, I can add more detail to the drawing, or even remove something which does not fit in the composition. Once the grisaille is finished and completely dry, I add colour in the form of transparent or translucent glazes. I then darken the shadows and apply colour to the objects in the painting. Once each layer is dry, I apply additional layers successively. This technique is quite a slow process because there are many steps before the colour can be applied. However, I find it very satisfying because of the luminosity which can be achieved.

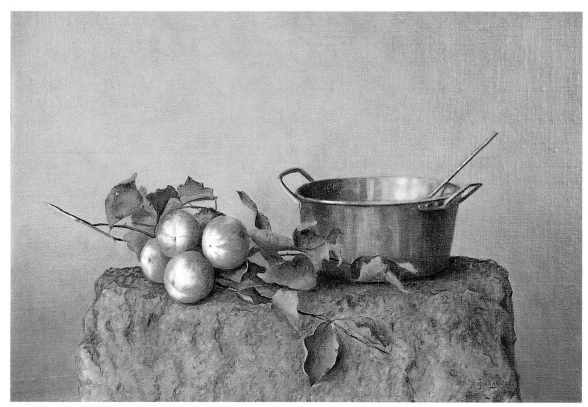

Kakis
20"x 30" (50cm x 75cm)

Kakis, or Japanese Persimmon as they are also known, originated in the east and are sometimes referred to as apples of the orient. They ripen to red-orange and look spectacular on the tree. Cañas contrasts their smooth, soft skins with the curled leaves, and metallic vessel.

Kakis

We were visiting a friend at his farm near the Andalusian town of Villa del Río. It was beautiful to see the fields full of sunflowers extending to the foot of the hills. I was gathering some to use in a painting that I had in mind, when I caught sight of some fruit trees of different sorts: figs, lemons, plums and kakis (also known as Japanese Persimmon). This last one in particular, was laden with fruit, which was not yet ripe. Our friend, Paco, broke off some branches and gave them to me. All in all, it was a wonderful day in the country.

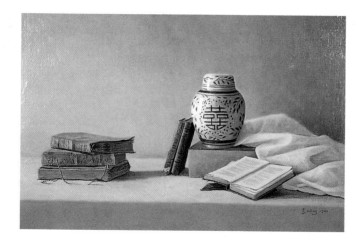

Old Castillian Books

" I was going through my books one day when a set of old ones caught my attention. Some of them are from the 17th and 18th centuries. As I browsed through them, I noticed the quality of the binding, and how well they were made. Some have goat-skin covers, and one of them has, on either side, leather laces which are tied when closing the book. I thought they could be interesting to paint. I picked up a few of them and looked them over. The pages had an old-looking colour and the covers reflect the passage of time. In this composition, the uniformity of colour is broken by the Chinese vase; the blue box and the red book, providing harmony in the colour tones.

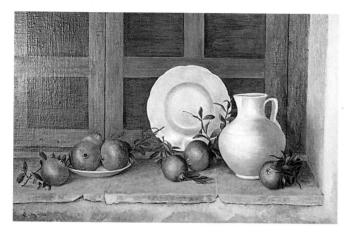

Window at the Third Courtyard

" It was a hot summer's day and I wanted to prepare a composition with pomegranates picked straight from the tree. The leaves were lush and the fruit had a lovely colour. I chose this patio window which was shielded from the heat by a grapevine. It looked out on to what had once been the horse stables in the third patio of the house, and the window-sill showed signs of age by the chipped tile and the faded colour of the clay. I had plucked the pomegranates from the tree, although they were not yet ripe. I thought the contrast of the greens, reds, and light yellows were beautiful in this natural setting.

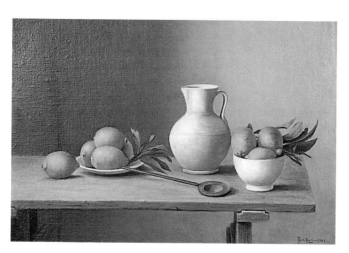

Midday Light on the Lemons

" It was a splendid sunny day and it was even quite hot. I came in from the garden with a basket full of lemons, ready to set up my composition. The white vase was already on the table, and I placed different objects next to the lemons, such as baskets, clay bowls, etc., finally settling for a simple white bowl and a plate which was also white. The yellow of the lemons created pretty contrasts, so I brought the table closer to the window to intensify the light in the composition. The focal point of the light is situated to the left of the composition where the window is, while the light falling on the back wall is less intense. I very much enjoyed painting this picture not only because I liked the composition, but also because I loved the scent of lemon which filled the studio!

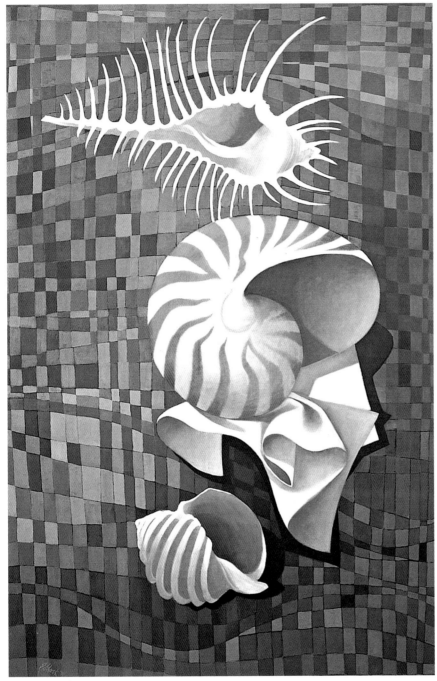

Using a more abstract composition, Hilary Pollock creates a dramatic image that combines graphic and painterly techniques. The viewer is left guessing the scale of the shells, selected for their contrasting shapes, making the composition all the more powerful.

Drawn from the Spell of the Sea
72"x 48" (183cm x 122cm)

"

Drawn from the Spell of the Sea

The greatest possible freedom is the act of creation. Although the experience can be both emotionally and physically exhausting, **the expressive qualities of colour and light combined with the seductive nature of the medium is very exciting.** *While for me this process is a very personal one, an artist needs to be aware of the impact of content, structure and colour on the viewer.*

A graduate of the National Art School, Sydney, Hilary Pollock currently works as an independent artist in the Blue Mountains of Australia. She has worked in animation, illustration, printmaking, painting and sculpture, and has exhibited in city and regional galleries. She has also won a number of awards, and has been included in the prestigious Blake Prize Exhibition three times. Her work is held in private collections in Australia, America, Canada, and within Europe.

This is the ship of pearl, which, poets feign,
Sails the unshadowed main, –
The venturous bark that flings
On the sweet summer wind its purpled wings
In gulfs enchanted, where the Siren sings,
And coral reefs lie bare,
Where the cold sea-maids rise to sun their streaming hair…

Year after year beheld the silent toil
That spread his lustrous coil;
Still, as the spiral grew,
He left the past year's dwelling for the new,
Stole with soft step its shining archway through,
Built up its idle door,
Stretched in his last-found home, and knew the old no more…

Build thee more stately mansions, O my soul,
As the swift seasons roll!
Leave thy low-vaulted past!
Let each new temple, nobler than the last,
Shut thee from heaven with a dome more vast,
Till thou at length art free,
Leaving thine outgrown shell by life's unresting sea!

The Chambered Nautilus
Oliver Wendell Holmes (1809 –1894)

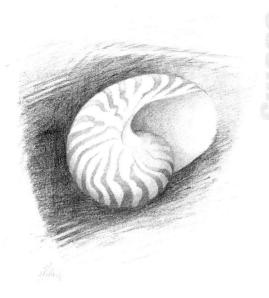

In Australia we have access to beautiful coastlines and abundant sea life. The initial inspiration for my picture came from a nautilus I found on a deserted beach. **The shape, colour and feel of this beautiful object were irresistible,** *so it easily became a drawing. I then tried a dry point/mezzotint, thinking a delicate yet dramatic approach was needed.*

It proved to be a stunning image for an etching and whet my appetite to push it further, from a 5"x 5" print to a 6'x 4' canvas. Quite a leap! Finding an image, a colour or a texture that arouses the sensibilities compels one to try it over and over with as many variations as possible. Some things become favourites and in time you build up a visual language of your own, never tiring of the sheer pleasure of painting them.

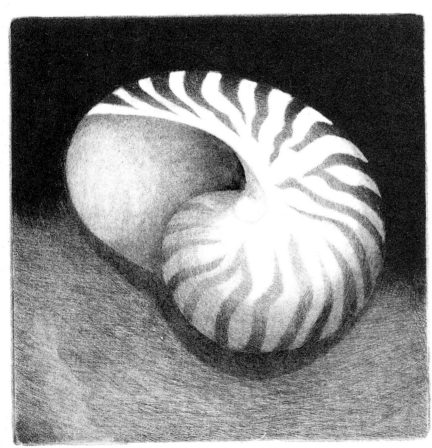

Pollock draws or paints objects that inspire her over and over again, exploring the variations that can be achieved through the use of different media. The nautilus shell proved an excellent subject for an etching.

'Drawn from the spell of the sea' was my second use of the nautilus in a painting – the first was in a palette of black, white and tan. Quite dramatic! The change of palette came when I decided to introduce the other shells for interest and the dusky pink of the smallest shell took my fancy. The greens and blues give a feel of the sea.

I like to start a picture with only a vague idea and let the composition emerge out of the physical process of painting. This allows for exciting discoveries along the way. **A picture will attract the viewer if it has an element of surprise** and if you work at the intuitive level it is not only easier but more interesting and exciting for you as an artist. Just plunge right in. At the same time you need to be objective about your work and not precious. **If something doesn't work – toss it away and start again!** This is the only way to get the masterpiece that is inside every artist.

Taking a large vertical canvas, (my favourite format and the opposite of what you would expect for a seaside image), I put the nautilus with its cloth centre stage. It was obvious the vertical needed to be emphasised so I placed the other shells above and below. This was done roughly with thin paint on a flexible brush. I then blocked in an all-over background colour in varying shades of blue to help establish the colouring and contrasts in the shells. **I wanted to keep a graphic background and discovered when I followed the shape of the shells it produced the feeling of waves and lines on the beach.**

The background colours were decided as I went, mixing one colour into another to vary the shades gradually and help push the shells forward. Some areas ended up with several colour changes and you have to know when to stop or you could go on forever having a psychedelic experience!

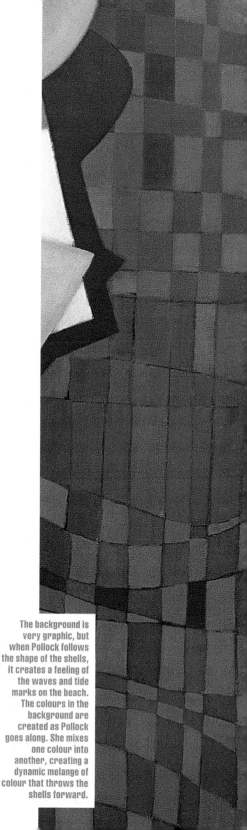

The background is very graphic, but when Pollock follows the shape of the shells, it creates a feeling of the waves and tide marks on the beach. The colours in the background are created as Pollock goes along. She mixes one colour into another, creating a dynamic melange of colour that throws the shells forward.

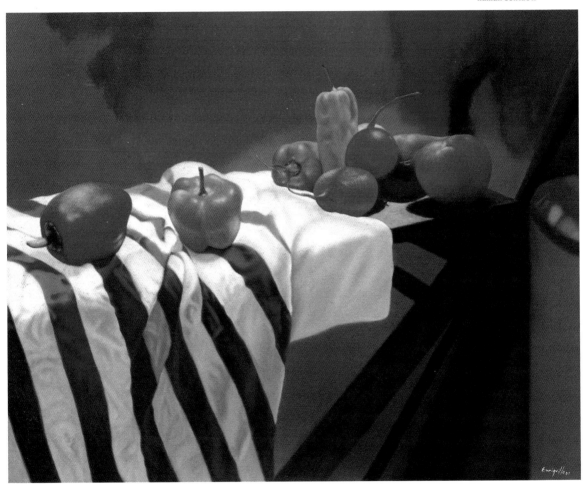

Metaphors
40"x 50" (102cm x 127cm)

Metaphors

For me, art begins with an idea, and because of that, I use a four-step process to help me generate and organise my ideas. The first one is to collect visual information for inspiration.

Enriquillo Rodríguez Amiama lives and works in Santo Domingo in the Dominican Republic where he was born in 1962. He studied Fine Art at the Nidia Serra Arts Centre, the National School of Fine Arts, the Autonomous University of Santo Domingo; and the Academies of A. Bass and S. Frias.

He has received a number of awards and honours at national contests, most recently at the XXI National Biennial, with an acquisition prize for the Modern Art Museum of Santo Domingo.

He has presented 15 solo art shows over the past 17 years, seven of them at international galleries in Montreal, Washington, Ciudad de Guatemala, Ciudad Panama and San Jose, Costa Rica. Additionally he has participated in more than 25 international group shows throughout North America, Latin and Central America, the Caribbean and Europe.

His work can be found in private and corporate collections in the Dominican Republic, Puerto Rico, Guadeloupe, Honduras, Brazil, Panama, Mexico, Costa Rica, the United States, Canada, France, Spain, Germany and the Netherlands.

Party
40"x 30" (102cm x 76cm)

Memories from the Old Town
40"x 37" (102cm x 94cm)

seeing

*Most of my paintings have a couple of mangoes, as symbols of the Caribbean people, love and life. Last year I wanted to add new themes and 'people' to my 'little universe' and was looking for new 'models'. Then I realised that vegetables and other bright coloured fruits could be interesting. **Colour is the first element that captures my heart,** after which comes form, shape, texture, and lines, etc. I went one morning to the old market, and started seeing and taking in all that moved my emotions and artistic feelings. The sellers sometimes looked at me like I was crazy, because I was only selecting produce by its colour or shape, but I didn't tell them that I wasn't looking for food – I was afraid that if they realised I was trying to create art, and not to buy my salad, they could raise the prices!*

thinking

With a big bag of pretty stuff, I returned to my studio, and started to meditate (my second step) about the colour relationships and how to combine all those different 'personalities' in a single work. I decided to concentrate on creating an interesting harmony of colour, forms and rhythm. Next day, with my fruit, cloths, and camera, waiting for good sunlight, I started working on my compositions.

*I take hundreds of photos – this is the third step! This isn't creative in itself, they are just good reference. With lots of photos, good and bad, the hardest part begins. I find my inspiration in collages and photomontages through a process I learned from Frank Almanzar, a great teacher at the National Fine Art School who told us about the Bauhaus and the decomposition and organisation of forms. **I take maybe 100–200 photographs of my still life set-up. When these are developed, I cut off the bottom section of the photos, so that I can be free with the objects, the linen cloths and the fruits (and vegetables).** Then the search for the compositional elements begins. I plan the colour, I look at the backgrounds of other pictures, I go through my reference photos of vegetation. A fragment of a Kandinsky might suggest itself, and so on. A three-hour session of trimming and combining might give me eight or ten compositions, sometimes none.*

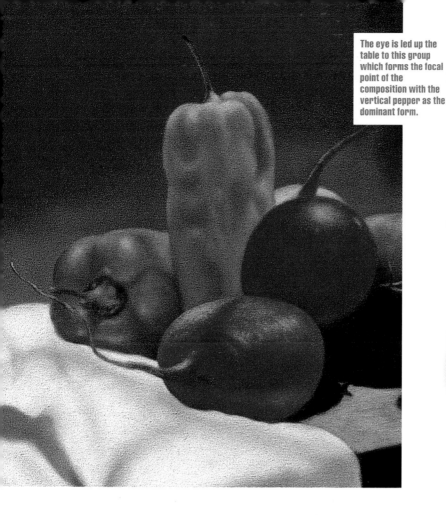

acting

I began by drawing fine and tenuous lines with a 2B pencil and coloured pencils, (they are cleaner). With very diluted acrylic colours I began the under-painting. It helps me to cover every line of drawing and cover the whole painting very fast. Some classical oil painters did similar water-based first layers in the early days of oil painting too. Of course, they didn't work with acrylics, but they used what they had, like tempera.

On top of this I developed the painting in traditional oil paint, and to achieve the atmosphere and the reality, I blended the oils with sable brushes, diluting them with a mixture of damar varnish, linseed oils and turpentine. The colour composition was a complex mixture of cool and warm colours, between green and red with a general hint of blue in nearly every colour.

'With an apple, I want to surprise Paris,' Paul Cézanne had said. 'With a mango, I want to surprise Santo Domingo,' Enriquillo Rodríguez Amiama could have said.
Marianne de Tolentino – President of the Dominican Association of Art Critics

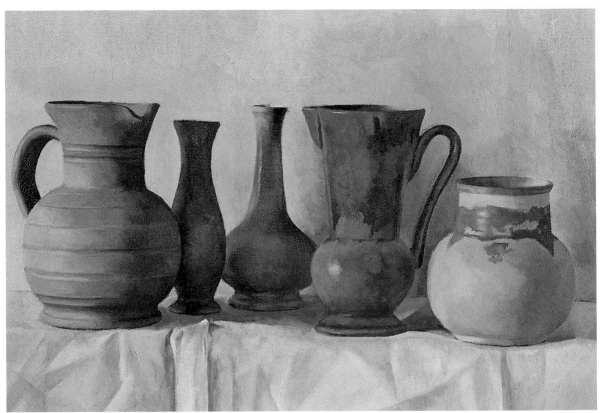

Iridescent Vases
12"x 18" (31cm x 46cm)

The objects were chosen to provide contrast between each other and to balance with the surrounding space. The stone jug on the right cannot reflect light in the same way that those with iridescent glazes can. Talbot creates further contrast by plunging some vases deep into the shadows whilst others are bathed in light.

Iridescent Vases

I define my work as realism, because I paint only what I see. **My aim is to present the subject with as much clarity as I can.** *This involves more than the recording of observation. There is always the problem of a fog of preconception coming between the painter and his or her subject, and it is dangerous to ever assume that there is a formula for success, or that what you did last time will work again this time.*

Born in Dublin, Ireland, in 1956, Robert Talbot studied Fine Art at Loughborough College of Art and Lanchester Polytechnic in Coventry (now the University of Coventry). He has been drawing and painting ever since he left in 1979, and now teaches in Coventry himself. Earlier in his career Talbot worked mainly in landscape, and when living in London, principally urban landscape, with a freer handling of paint. His style has changed to a more formal approach, and he is interested in applying this technique to landscape also. For his still lifes, he has found inspiration in a variety of artists including Juan Sanchez Cotan, Francisco de Zurbarán, Chardin, and the cool monumentality of 20th century Giorgio Morandi.

Talbot's paintings have been exhibited throughout London and the Midlands, and can be found in collections in the United Kingdom, the United States, Italy, Spain, and New Zealand.

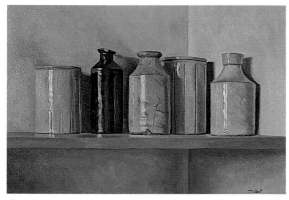

Stone Jars
16"x 22" (41cm x 56cm)

Table *and* **Pears**

*I came across these two vases with iridescent glazes in a junk shop, and I wanted to see what it would be like to try to capture the way they trapped and reflected light. **At the back of my mind I think I had recently seen some Piero della Francesca's and I was kind of trying for some of the luminous powdery colour of his work.***

The iridescent surface of the vases seduced Talbot into buying them. They pose an interesting challenge to the artist, trapping and reflecting light.

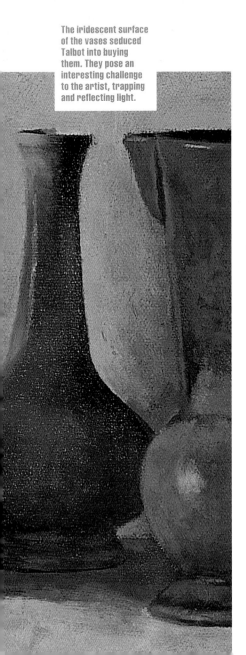

The composition was developed through a series of drawings. I was particularly concerned about the balance between the objects and the space between and around them. The other objects in the painting were there to provide contrast and an extension to the theme. The stone jug on the left stops the light, with no reflections in the surface, whilst the white jug on the right adds lightness and advances the edge of the composition. The small vase, which is completely in shadow, is there to emphasise the evenness of the light in the main part of the composition.

*I wanted a light painting so I pinned some lining paper behind the objects, and used the white cloth for the foreground. Rather than have the light all cast from one side **I wanted to see if by using reflective elements in the foreground and background I could get the light to envelope the objects to some extent,** instead of fading out away from the source. The composition was arranged on a shelf near eye level to suppress perspective and emphasise the horizontal play of light across the objects.*

Occasional additions: Lemon Yellow Cadmium Violet

This painting is very light, with the drapery selected to hold the reflected light, enveloping the objects. The modulations of tone and colour found within the back wall create the atmosphere of the set-up.

When I was satisfied with the preliminary drawings I measured out the main proportion of the composition on to the canvas. I then primed the canvas with size and Lead White. The Lead White ground yellows slightly with age, softening the tones. I put in the large areas of colour in thin washes as quickly as possible, so that I could see what I was dealing with. I could then begin to judge the tonal and colour relationships to get the feel of the light in the painting. I only work on a painting for a couple of hours at a time, because after that the light has changed too much.

I worked in layers, working from lean to fat. The first layers were diluted with turpentine, and then I gradually added oil to each successive layer. For the first couple of layers I used refined linseed oil, and then I changed to stand oil. The final layers usually include quite a lot of glazes. A favourite technique of mine is to paint glazing medium with no colour on an area of the painting, and then paint into this so that the colour melts and spreads.

I always find a particular challenge in a painting like this in dealing with the cast light across the wall at the back. Light does not spread evenly over a flat wall. Getting the changes of tone and colour temperature can be as challenging as anything else, but it is really important to the feel of the painting.

A FAVOURITE TECHNIQUE

Talbot likes to use a lot of glazes. By using a colourless glazing medium, and then painting into it, the colour spreads, producing a soft and interesting effect.

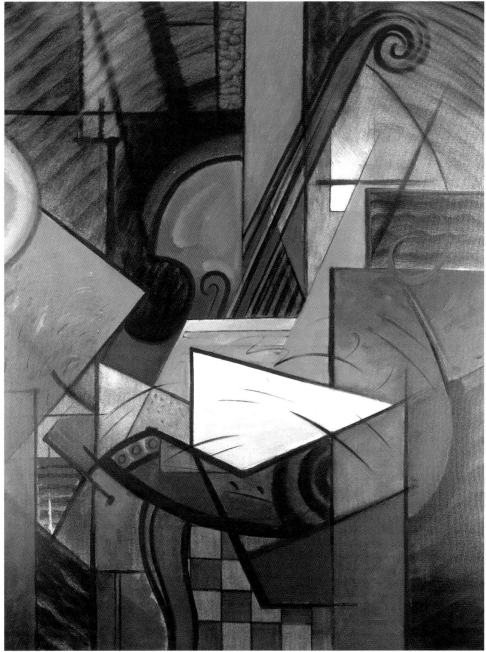

This very rich, abstracted image draws inspiration from the cubists with its fragmented surface broken into large planes of colour. Like most of his still life subjects, this image allowed Ilibayev to create a vision from his imagination, making it very personal and summing up his mood at that time.

Muzik
46"x 35" (116cm x 89cm)

Muzik

" To me, artistic reality is a different kind of reality, which touches physical reality with its wing, like a bird rising from the water. In art, one must fly above things; one must look at oneself as though from the heights, not getting entangled in trifles. One must be merrier and freer. It may be even advisable to be superficial, because the Muse, like any woman, does not bear being bored. **Still life is a special genre for me. One thinks of it as representational of material reality, but for me it can be a compositional fantasy. I don't paint what I see in front of me, because I am free to choose the form, objects and contrasts.** My still lifes are a reflection or meditation on a particular subject. Their foundation is my memories or just a mood.

Born in Ventspils, Latvia, in 1952, Vladimir Ilibayev went to school in the Urals and graduated from the Sverdlovsk Higher Military Political School in 1974. He entered the Department of Philosophy at Moscow University in 1976 but left after the second year, having participated in exhibitions since the beginning of this course. He went on to study the painting of icons at the Greek-Orthodox monastery in Vilnius and worked as restorer of paintings and icons. In 1988 he graduated from the St Petersburg Fine Arts Academy.

Ilibayev is one of the founders of the Moscow artists group Vernisage (1987), the Free Art group in Riga (1989) and the Association of Russian Artists of Latvia (1997). He has hosted a number of antiquarian auctions and has continued to work with icons, including five personal exhibitions. His paintings can be found in private collections and galleries including that of Mikhail Barishnikov in Paris.

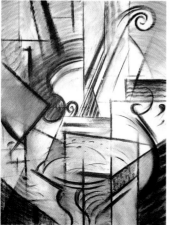

The inspiration for the painting was this photograph of a charcoal drawing of another painting that had been stolen!

The preparatory drawings Ilibayev makes for his paintings make striking statements in their own right. He values the unity of monochrome images, and the fact that they clearly do not represent reality.

The world of still life is one of rest and homeliness — somewhere to shape my inner vision. **I work in series, maintaining a theme and allowing each composition to suggest a new approach or compositional structure.** *This painting was created from a photograph of a charcoal drawing of another painting that had been stolen from the Hotel Radisson!*

The particular focus of my still life painting at the moment is form or structure. *My works are constructed in my head, and are not constrained by actual colour or form. In contrast to abstract paintings, to which I also devote much time, this task is more difficult and interesting, because I am defining the theme for improvisation, as in jazz. The viewer is also free to choose his associations, but he is more guided by the concrete content suggested in my composition.*

Building a composition is quite a complex matter. Obviously here I had the photograph to guide me, but sometimes I develop my composition from a little sketch. On other occasions I work straight on to a big canvas starting with a charcoal sketch to guide me. **A sketch can become a piece of work in its own right. Working in monotone there is a unity about the image, and the tonal relationships are so much easier to appreciate.** *Furthermore, in black and white there is no illusion of reality.*

Ilibayev pulls his images together by adding coloured accents and lines. These serve to bring disparate areas together or to fine-tune the balance of the composition overall.

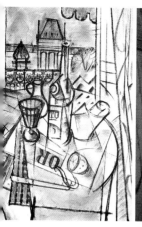
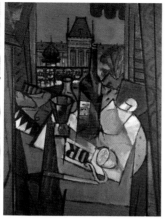

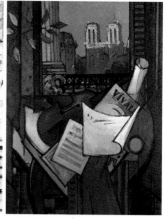

Still Life with Lemon
After a visit to Paris, Ilibayev brought back many memories including that of arriving in the city and having a coffee in a city café. The beautiful view from the window inspired him to develop an inspiring cycle of drawings and paintings.

Still Life with Violin
This painting became a continuation of the Paris cycle, synthesising the compositions 'Muzik' and 'Still Life with Lemon'.

acting

I drew this image in charcoal, straight on to the canvas, full size, and then worked over it with oil. **To ensure the correct tonal balance I started painting using thin transparent coloured layers. In other words, over the fixed charcoal drawing, I just flooded almost the entire painting with a coloured transparent cover and then started to develop the image by adding further colours.** *I worked first on the large planes, and then on to the smaller areas. Then I needed to unify the two, balancing each against its neighbour – for this I needed to enrich them all with tone and colour. Finally I added the accents and precise lines to give the composition its clarity and emphasise its inner dynamics.*

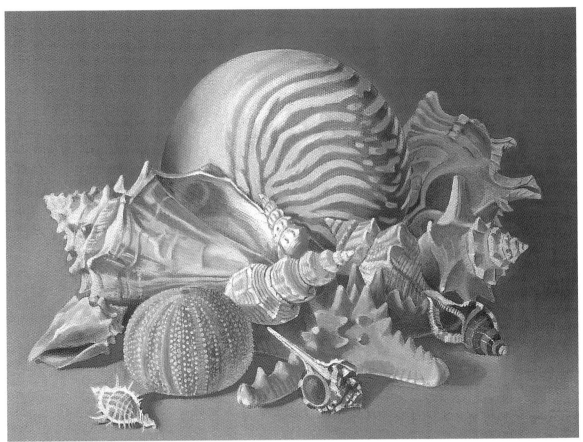

Jolyon's Treasures
10"x 12" (25cm x 30cm)

The structure of any shell is interesting in itself. Their beauty and diversity are shown in this painting by Judith Carter, which contrasts their individual forms, colours and textures.

Jolyon's Treasures

From an early age my son collected exotic shells, steadily building a substantial collection. Having dusted them for years, I knew them intimately, and as a family we have all drawn upon them at some time or another for school art homeworks or still life studies. I greatly enjoy painting natural objects, revelling in the purity of the forms, and subtlety of colour. ***However beautiful a man-made object, there is something fundamentally more satisfying and universal about holding and beholding the bounty of nature.***

Born in London in 1933, Judith Carter began her training at Ealing School of Art and went on to work for Victor Steibel, fashion designer for royalty and leading actresses of the day. Further study at Hastings Art School in illustration and embroidery led to a career as a teacher of art and an early years educationalist. She has been greatly inspired by her travels to Russia, Israel, and Italy, and her work in oils, pastel and print has been exhibited at numerous exhibitions in the South East of England and the Midlands, including the Westminster and Llewellyn Alexander Galleries in London, and the Montpellier Gallery, Stratford-upon-Avon. Examples of her work are held in various private collections and in the permanent collection of the Tunbridge Wells Museum and Art Gallery.

Poseidon's Gifts
10" x 12" (25cm x 30cm)

rodin Art is contemplation. It is the pleasure of the mind which searches into nature and which there divines the spirit of which Nature herself is animated.

We are naturally drawn to things of beauty, and have an innate desire to record them. Much of the history of still life painting is testament to this fact. Collecting pebbles and shells as the tide recedes is an almost instinctive human activity, and when we bring them home, we carry with them memories of those moments spent at the water's edge; reflective moments; relaxing moments; holiday moments.

My son's shells just cried out to be painted. Their multi-faceted surfaces, and contrasting geometric structures intrigued me, and I was keen to show their diversity. **With such tactile forms it is important to hold the objects, feeling their external and internal structures to appreciate the angles and curves of the spirals, and the relative sharpness or smoothness of the shells' surfaces.** This way you can also visualise the internal chambers of the shells in the same way you can appreciate the human skeleton in life drawing.

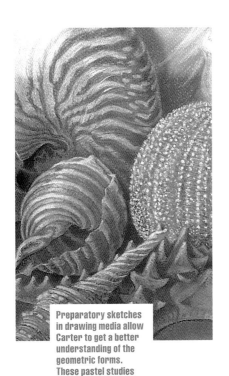

Preparatory sketches in drawing media allow Carter to get a better understanding of the geometric forms. These pastel studies focus in on specific elements of the overall composition and create interesting studies in their own right.

Before I worked the subject in oil, I first experimented with studies and compositions through a drawing medium, pastel, to more fully appreciate their geometric volume. Drawing is an important activity for me; I often make sketches of my subjects and these can become works in their own right, or starting points for prints or paintings.

I loved the contrast between the sweeping, smooth curve of the nautilus shell, the spiky murexes and noduled sea urchin. **Having spent a great deal of time studying and working in textile design, I am drawn to subjects with pattern and textural contrasts.**

Schooled in the Dutch masters, it seemed natural to create a traditional broadly pyramidal composition, setting the larger forms towards the rear of the arrangement, and then piling up numerous smaller shells to accentuate the sheer variety of God's creation.

This drawing was undertaken in preparation for a detailed etching. The repeated shapes of the skulls combined with the sweep of the grass resulted in a rhythmic mysterious print.

*I worked on stretched canvas, primed with gesso, first blocking in the main shapes in a light, dilute Ultramarine. I then loosely painted in the background using a blend consisting mainly of Raw Sienna and Crimson Alizarine. I didn't want to cover the entire canvas, since **I wanted the white of the canvas to reflect through the shells to suggest their delicacy.** The coloured background, however, made it easier to judge the colours – a bare white canvas can result in applying the colours too light. Shells have a natural colour harmony despite their apparent variation. I always use a limited palette, in this instance including Titanium White, Cadmium Yellow, Yellow Ochre, Raw Sienna, Vermilion, Crimson Alizarine and French Ultramarine, with a little Venetian Red and Burnt Sienna. Painting still life, and things like shells in particular, is a relatively relaxing activity. There are few distractions, the lighting can be controlled, and here there is no chance of anything wilting, twisting to face the light, or putrefying! As a result, I was able to return to the painting over a period of days to reconsider its overall harmony.*

Carter always uses a limited palette:
Cadmium Yellow
Yellow Ochre
Raw Sienna
Vermilion
Crimson Alizarine
French Ultramarine
with a little
Venetian Red and
Burnt Sienna

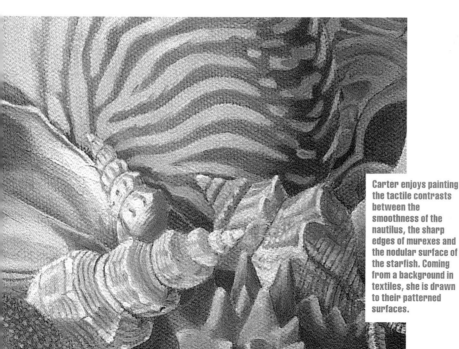

Carter enjoys painting the tactile contrasts between the smoothness of the nautilus, the sharp edges of murexes and the nodular surface of the starfish. Coming from a background in textiles, she is drawn to their patterned surfaces.

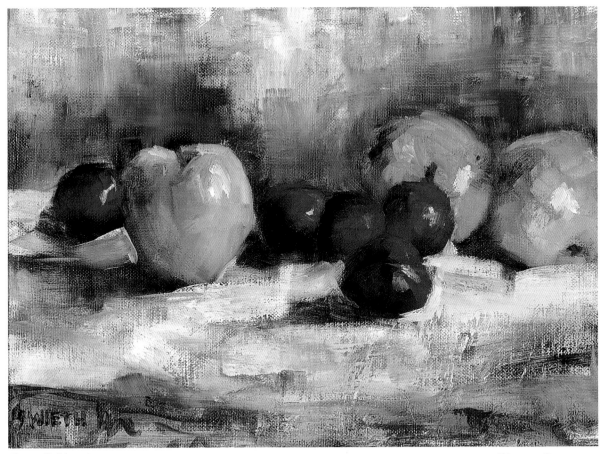

Granny Smiths
by Richard Wieth

This textural image was created very quickly, painted directly using a lot of dry brushwork on the foreground and background. Wieth's aim was not to define every last detail, but to capture the luscious contrast between the green apples and the maroon plums. The overall effect is loose and painterly.

Apples
by Timothy Tyler

A smoother surface than Wieth's 'Granny Smiths', Tyler's shiny apples look so real that you can almost taste them.

Glassy smooth or violently textured, the use of the brush or the knife, communicates the personality of the artist and their response to their subject. Oil paint is capable of achieving an amazing range of surfaces.

In the 17th century most artists endeavoured to disguise any evidence of brushwork, creating smoothly blended surfaces with photographic realism. The uniformity of this kind of formal painting means we can glean little knowledge of the artists behind the brushes. However, as the commercial art market began to evolve in the 19th century, artists, no longer dependant upon commissions, were able to generate work that expressed their feelings about their subjects and life itself. The defined outlines of the classical mode of painting gave way to the dynamic edges of the painterly approach that steadily loosened until the impressionists totally broke the surface, applying their paint in staccato dabs. Taking this further, artists such as Van Gogh, Munch, Schmidt-Rottluff and Nolde used incredibly thick paint, to the point where their works began to look three-dimensional. Their comma-like, jabbing or swirling brushwork reveals the passion with which they applied their colour, earning them their expressionist title.

Artists today work in both the smooth classical and the more textural painterly styles. M Kathryn Massey, Kristine Diehl and Timothy Tyler are amongst those who create images that are photographically real, with little trace of the brush stroke. By contrast, Karel Schmidtmayer is inspired by the plastic quality of oil, using its bulk to make imprints of objects, and even adding collaged materials to enliven the surface. Melding text and image, Roberta Morgan uses a richly textured surface to convey the multi-layered quality of life in the 21st century, whilst Richard Wieth and Peter Graham use a loose, painterly approach creating a dynamic surface with brush strokes fully visible.

Detail previous page:
Measure
by Roberta Morgan

Here, in a collection of tools, Morgan creates an interplay of text and image. She suggests that as you become familiar with the upper layers, details underneath reveal themselves, making your interaction with the piece continually refreshing and unpredictable.

The smooth surface and horizontal format emphasises the restful atmosphere of this still life. Through its realism the viewer can easily imagine relaxing at the table, sipping aromatic continental coffee.

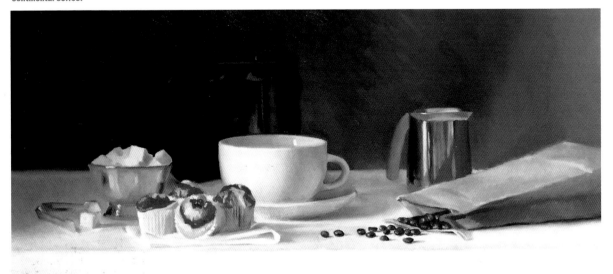

Coffee Still Life
12" x 25" (30cm x 63cm)

Coffee Still Life

In my still lifes I try to go beyond just a pleasant arrangement of objects. ***Each element plays a part in my attempt to visually describe a feeling or memory,*** *and how they are composed determines the associations that the viewer will make with the painting as a whole. I find that the artistic language that best serves my purposes is realism, and I work exclusively from life.*

"

Martini Still Life

My 'Martini Still Life' was created in much the same way as the coffee one. It is a texture piece, with the contrast of the smooth glass bottles, the soft fur of the stole and the wet olives swimming in the jar. **I had to keep in mind how to make things look like they 'feel' right.** The attraction to this particular subject had to do with the glamorous association I have with the procedure of mixing a Martini. From the elegant bottles of gin and vermouth to the signature glass; the olives, added as the finishing touch, to the opulence of the fur stole and graceful arrogance of the cigarette holder and silver case; there is an air of mystery, which is both aloof and, well, fun.

At just 24, Kristine Diehl has been drawing and painting in the tradition of classical realism for almost ten years. Introduced to the method at local art centres by Atelier-trained instructors, Diehl has been training her artistic eye throughout high school, college and beyond. As a student of the University of Minnesota she participated in two foreign exchange programmes in Austria and was able to study paintings of the masters first hand in museums throughout Europe. After earning her B.A. in Art History and German Linguistics, Diehl decided to attend The Atelier in Minneapolis, Minnesota as a full-time student. Her work has been recognised by the Art Renewal Centre in America.

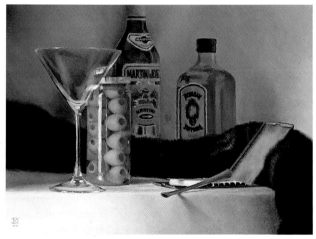

Martini Still Life
13" x 18" (33cm x 46cm)

Self Portrait

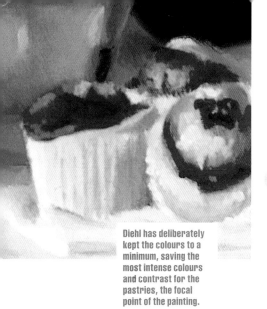

Diehl has deliberately kept the colours to a minimum, saving the most intense colours and contrast for the pastries, the focal point of the painting.

seeing

The inspiration for my 'Coffee Still Life' came from memories of studying abroad in Austria and the many hours I spent in cafés. **I wanted to evoke the restful atmosphere of those cafés, with details like the smell of the freshly ground beans, the sound of the coffee cup clinking on the saucer, the sweet taste of pastries enjoyed with the coffee** – a sense of warmth, comfort and relaxation. I collected a variety of objects that reminded me of this experience, brought them to my studio, and began the process of setting the stage to tell my story.

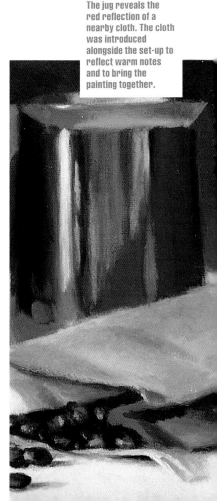

The jug reveals the red reflection of a nearby cloth. The cloth was introduced alongside the set-up to reflect warm notes and to bring the painting together.

thinking

To orchestrate this idea I used classical principles of composition such as the long horizontal format of the painting to portray a feeling of rest. **I kept the colours of the different objects to a minimum and saved the most intense colours and highest contrast for the focal point of the pastries next to the coffee cup.** There was also a lot of just plain experimentation. I moved the objects around, adding something here, taking something away there, and always standing back to see if it worked as a whole. **I then hung a red cloth to the side of the still life set-up in order to reflect warm notes into the objects and unify the image.**

After reaching a point where I was generally satisfied with the composition, I started a charcoal drawing. My drawing-board was placed next to the still life set-up and I began drawing it life size. After spending a few days on the drawing I decided that the composition was somewhat unbalanced due to the weight of the coffee beans and bag on the right side. As a solution to this I added a pair of sugar tongs and a stray sugar cube to the left of the pastries.

The initial drawing was done in vine charcoal and used to work out compositional details and to determine the size and cropping of the piece. After stretching the double oil-primed linen to size, I used the drawing to transfer the outlines of the big shapes on to the canvas as a guide for the first layer of paint.

I use what is referred to from my classical realism training as the Paxton palette, after William MacGregor Paxton. It is a balance of about ten colours, including Raw Umber, a variety of Reds, Yellows, Ochre, Blue and White. *I don't use the Black until the very end, (and sometimes not at all), in order to keep colour intensity and vibration in the dark values.*

In the lay-in stage I go for the large value patterns using simplified colour. Basically, I am expressing the values as light or dark, warm or cool, and making sure the placement is on target. As the painting progresses, I refine the drawing, adjust values, and take more precise colour notes. In the refining and finishing stages I take on smaller passages and work out the relationships between objects, find any drawing details that need to be adjusted, and add subtle value and colour nuances. Over the entire duration of the painting I keep in mind the overall look of the piece. Standing back a few feet from the painting and comparing it with nature is key.

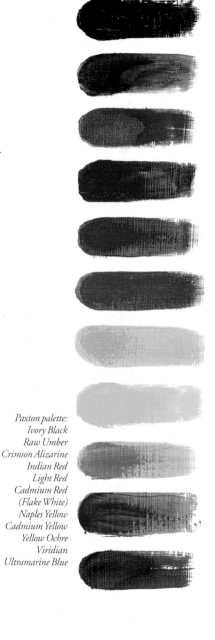

Paxton palette:
Ivory Black
Raw Umber
Crimson Alizarine
Indian Red
Light Red
Cadmium Red
(Flake White)
Naples Yellow
Cadmium Yellow
Yellow Ochre
Viridian
Ultramarine Blue

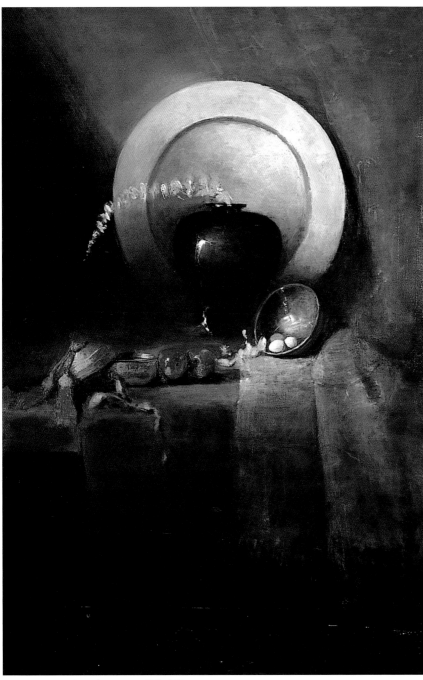

This dramatic still life is concerned with the movement of light into darkness. There is a sense of luxury and mystery, a smooth surface, a rhythm of curves, and areas of interest highlighted in theatrical pools of light.

Composition with Apples, Eggs, and Black Vase
40"x 30" (102cm x 76cm)

...The object of art is not to reproduce reality, but to create a reality of the same intensity. **giacometti**

"Composition with Apples, Eggs, and Black Vase

A student of mine, once asked me, 'Do you talk to yourself when you paint?'

I looked at her and said, 'I always have a dialogue going with myself.' Thinking about her question now, leads me to the notion of moving through a painting from the initial idea, or what is it you see, or want to see, to its completion. For me, seeing begs the question, **'What is the concept I want to paint?'**

Turkish Vase on Rug
22"x 28" (56cm x 71cm)

M Kathryn Massey is a painter whose work is grounded in the old masters, with an eye to contemporary sensibilities. She holds a bachelors degree in Music, and moved to Nashville, Tennessee in 1980 to pursue a career as a writer and performer. In 1994 she decided formally to paint and began private and independent study. Massey has most recently studied with David A Leffel and Gregg Kreutz at the Art Students League, New York, and the Indianapolis Art Center, Indianapolis, as well as in Scottsdale, Arizona, Lovelend, Colorado, and the Fechin Art Institute, Taos, New Mexico.

She is interested in capturing form, through an understanding of light and its movement. Rembrandt, Vermeer, Velázquez and Whistler are artists who have inspired her, as well as Rodin who had the ability to capture movement in his sculptures.

Massey has won numerous prestigious awards and has exhibited her work throughout the United States. She is a Board Member of the Indiana Committee of Women Artists amongst other commitments, and she teaches on request. She is a member of a great many professional organisations, including the American Artists Professional League, New York, and an Associate Member of both the Oil Painters Society of America, and the American Academy of Women Artists.

Seeing is looking beyond the array of objects that I have chosen to the more abstract idea. In the case of 'Composition with Apples, Eggs, and Black Vase' I wanted to paint more than the literal objects. **I always choose objects that I like or have some meaningful connection to me.** *The shapes within the group appealed to me along with the colour of the apples and blue robin eggs. I liked the drama of the black glass vase and the complementary gold plate at the very back of the painting.* **My overriding idea was to create the impression of light moving from front to back, light to dark, and to move the viewer back into the painting.**

The eye enters the painting at the box on the left, but settles on these richly red apples before moving on to the pool of light beyond.

MASSEY'S MEDIUM MIXTURE

Massey's medium is maroger, which is made of cold-pressed linseed oil, spirits of turpentine, mastic crystals, and litharge. It derives from an old recipe of Jacques Maroger (1884–1962), a French painter and restorer. She uses it to thin the paints and also to tone a canvas, mixed with a little paint.

TINTED GLASS PALETTE

To enable Massey to judge colours accurately she uses a palette made of glass, tinted on the back with Umber. Her colours can then be seen on the palette as they will appear on her tinted canvas. If using a glass palette, though, be very careful to bind the edges to protect your hands.

The idea was to create a sense of moving the light from the open round box on the table's edge, over the red apples and into the tilted bowl with the eggs. The light lands there, but then your eye wants to see what else is there and so it moves to the black vase and over again by way of the eucalyptus stem in the vase. When you look at it in an abstract way, you can actually see an inverted 'C'. By having the ability to 'see' this before I began, I was better able to choose the kind of objects I needed and their placement – both of which supported the notion of light and dark and its movement back into space.

I use a relatively limited palette of colours for the sake of greater harmony and cohesiveness. The palette I use to mix paints is made of glass tinted with Umber on the back so that I am not using a stark white space. The same holds true for the surface or support I use. This image was painted on a linen canvas toned with Umber and Pthalo Blue. **A toned canvas kills the white and creates a surface that doesn't allow for the paint to 'sink in'. It also creates a surface that draws you in rather than repels you back which is what large areas of white tend to do.** *White anything also draws the eye's attention and so you want to neutralise this element from the very beginning. I also find a toned canvas gets me ready to paint.*

Keeping in mind my overall concept, I set up this still life to move the viewer from front to back with the centre of interest in the fullest or most dramatic light. **The box begins the painting on the left, the eye follows the placement or trail of apples and the end comes with the light on the blue eggs in the bowl.**

On a toned ground, I massed in the bowl of eggs, large vase and other objects a little smaller than life size, and established how high or low the table line would be. Massing provides a more solid idea of the end result, as opposed to line drawing which provides no sense of weight or separation of the foreground from the background. When I was sure about where the objects were going to rest in the picture, I proceeded to put in the shadows of all the objects. The background was painted next. Following these steps, I could begin to see the overall effect of how the painting was going to work. At this point in a painting the effect of light should be evident and the objects should look solid. It should also be clear what the centre of interest is. Until now, you can just use Pthalo Blue and Umber to create the size, placement, foreground and the background.

After this, I began applying local colour, for the box and apples, etc., and moved through the painting so that all objects had a lighted side and shadow side with its local colour.

It can't be stressed enough that **I watch my painting and not the set-up** throughout the entire process. By doing this I can immediately notice if a brush stroke, value, colour or even an object is not supporting the overall concept. I do not try to copy the set-up which is a grouping of inanimate objects, but rather, I track very closely what is happening on the canvas, always asking myself if what I am adding contributes to that final outcome I want. **What is happening on the canvas is more important than the objects on the model stand.** This is true for all painting whether it's portraiture or landscape. Each brush stroke must unify and support the greater abstract idea with which I began. Painters get into trouble when they put down paint strokes, but don't know why they are doing so. They are not 'attending' to the painting. They are painting without an idea.

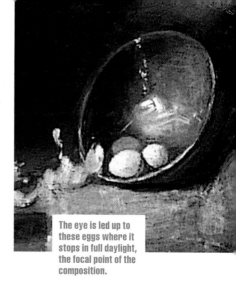

The eye is led up to these eggs where it stops in full daylight, the focal point of the composition.

" Painting in north light provides a natural, clean and consistent light source. Try not to use photos. I would recommend painting from life if at all possible, the experience will be far richer and instructive.

Optional extras:
Transparent Oxide Red
Cadmium Orange
Cobalt Blue

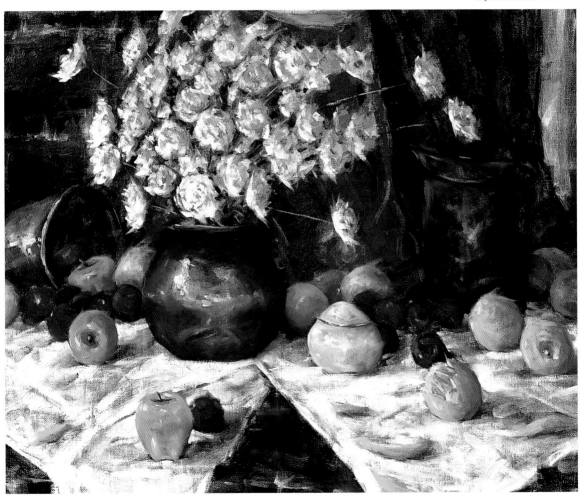

Richard Wieth has created a busy composition that encourages the eye to move all over its surface, although the blue pot remains the focus of attention. He has deliberately worked some areas more intensely than others to create a kind of visual hierarchy where some elements are of less importance than others.

Artist's Table
28"x 34" (71cm x 86cm)

Artist's Table

I would like everyone who looks at my paintings to know for a moment the beauty of the simple things in life. I think that all too often people get caught up in details and fail to appreciate the enjoyment of simplicity. I do not attempt to paint photographically, (although that is sometimes the result). **I paint with an impressionistic style that I believe lends itself to adding mystery and expression.** I think that art is true self-expression, each brush stroke or lack of brush stroke conveys emotion and self-expression. I put a lot of faith in the viewer that they will be able to piece together the mystery, without spelling out every detail. This interaction will help the viewer enjoy the moment of time that I am creating. I would love it if people could see the simplicity of still lifes in their everyday environment or the deeper beauty of their pets or the stranger on our streets. I feel all of these subjects, in their moments of simple beauty, must be rendered.

Richard D Wieth has been interested in art for all of his 35 years. He graduated from the University of Denver in 1989 with a BS in Marketing and a minor in Graphic Design. Feeling unfulfilled in the business world, Wieth returned to the arts in 1992. With instruction and encouragement from his friend and mentor Ramon Kelley, he began painting a forest of canvases in both oil and pastel. He enjoys painting still life, people, animals and the different cultures of the world. In 1995 Wieth embarked on his full-time professional painting career. His artistic career has left him fulfilled and challenged, and his work is in private collections in Japan, Australia, Colorado and the American West.

This painting was inspired by a larger canvas hanging around the studio. I don't paint particularly huge works. My paintings tend to be more intimate. Jennifer, my wife, had some beautiful flowers around and I found myself arranging a large and somewhat ambitious painting. I included a variety of studio props – a favourite cobalt blue pot, drapery, and, of course, fruit. **I wanted the set-up to look random and I included elements that could be individual paintings in their own right.** As with Fechin's 'Indian Summer' painting, shown here, I wanted to have areas of abstraction, areas approaching realism, and most importantly, for it to be entertaining and interesting to the eye. I wanted the viewer to look all around the painting.

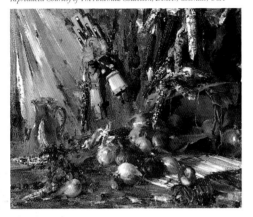

Indian Summer
by Nicolai Fechin 1881–1955
Reproduced Courtesy of The Anschutz Collection, Denver, Colorado, USA

" I have been greatly inspired by the work of Nicolai Fechin and have been fortunate to become particularly familiar with four of his paintings in the privately owned Anschutz Collection. Phillip Anschutz owns this beautiful example of Fechin's still lifes. I study it often. Every time I look at it I see new things and get new inspiration. All of the elements are very harmonious. Colour is everywhere and the angles draw your eye around the painting. My favourite aspect of Fechin's work is his dry-brush technique. He would layer the paint with very little medium, painting very directly and with confidence. This technique creates beautiful texture, edges and transparency. He was a master at making painting appear carefree, leaving things just finished enough and leaving areas of beautiful abstraction.

The large canvas that I had around the studio was a rough stretch linen primed with rabbit skin glue and Flake White. I like to use a large palette which includes a lot of pure colours, even though I grey most colours down. Painting a still life in a large format with a lot of objects creates many problems that one must solve. Everything must be harmonious. You don't want it to look like you painted just a bunch of stuff. You don't want anything to look like an orphan or out of place. But as always with all still lifes, some players are more important than others. **There always has to be a focus, and in this case it is the blue pot. The white flowers and tablecloth and all the other props are merely the supporting cast.** That is why I didn't 'spell out' many of the other objects. The other main problem with painting big paintings is a tendency to paint the objects larger than life. Whenever that happens things become less believable and you are putting more pressure on yourself. I think that any representational painting is best when the subjects are kept to life size or smaller. You can't just paint the objects bigger to fill up the space.

The overall design and tonal composition is established with a sketch. Mid-tones are added first, followed by the darks, and then the lights.

*I have settled pretty much into a particular process for painting. This doesn't mean that I don't take chances or vary my techniques, but I have found good results using this formula. I sketch everything first, in a combination of Yellow Ochre and Cobalt Blue, looking mainly for design and tonal designations. I tend to paint quickly but methodically, following the initial sketch with my middle tones. I like to work the colours all around the painting – I don't want any of them to feel alone. The darks go in next, generally a little darker than I see them because, especially in oil, it is easier to bring things up the tonal scale than down. I like to keep my darks lean, i.e. not thickly painted, although I build up the thickness of the paint as I progress. I then put in my lights and highlights, and at this stage I really slow down and work deliberately. **With my lights, I like to use the dry-brush technique, dragging the brush over areas of dark, creating areas of transparency that are determined by the texture, (or tooth), of the canvas.** The dry-brush style can also create pleasing fuzzy edges. I generally use bristle brushes for the main part of the painting (filberts and flats), and a sable for softening the edges and blending near the end stages. Finally the highlights are put down and left.*

" I like a large palette even though it would be cheaper to use a smaller one. I also often try out other colours for experimentation. I am a colour pig!

Using a dry brush, Wieth creates texture and a sense of transparency. He completes the painting by adding the remaining highlights.

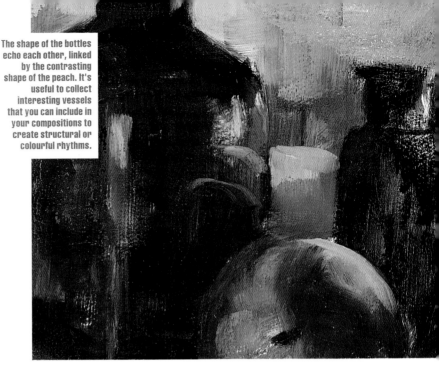

The shape of the bottles echo each other, linked by the contrasting shape of the peach. It's useful to collect interesting vessels that you can include in your compositions to create structural or colourful rhythms.

Ripe Peaches

"The colour of these peaches really captured my attention. I placed them with some old bottles, to add vertical elements to the still life, and thought the contrast of the smooth glass texture with the fuzzy peaches would be interesting.

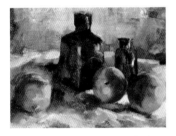

Cobalt Bottle

"I love the contrast between the colours of orange and blue, and I love to paint juicy oranges. Oranges create so many different interesting shapes in the process of being peeled and I wanted to set this off against a simple set-up using a white tablecloth, a little cobalt blue bottle, and a dark background.

DRY-BRUSH TECHNIQUE

Wieth follows Fechin's method of using the dry-brush technique for his lights. He drags the brush over dark areas to create transparent effects determined by the texture, (or tooth), of the canvas. He also uses this method to create soft or broken edges.

Onion Spill

I have always enjoyed painting onions. I like the different colours to be found as they are peeled, and I enjoy the random shapes created by their skins. On this day I chose to paint the same variety of onion. They had been sitting in my studio for a few days stored in a brass bucket. I literally took the bucket and turned it on its side and let the onions spill out. Some had been partially peeled. With a few slight adjustments of the foreground onion and some of the peels, the still life was set. I really made a conscious effort to have the peels of the onions move the eye around the composition. Even the wrinkles in the drapery were fairly deliberate. **I was trying to achieve a painting that had the appearance of being very spontaneous, and wanted to bring the viewer into an intimate space and time.** *I did not, therefore, give any importance to the background or foreground. The viewer is right there in the midst of the onions.*

Although mundane, onions are fantastic subjects to paint, offering variety of colour, shape, texture and translucency. Wieth aimed to create a casual, spontaneous composition, using broken, impressionistic brushwork, compatible with the domestic nature of his subject.

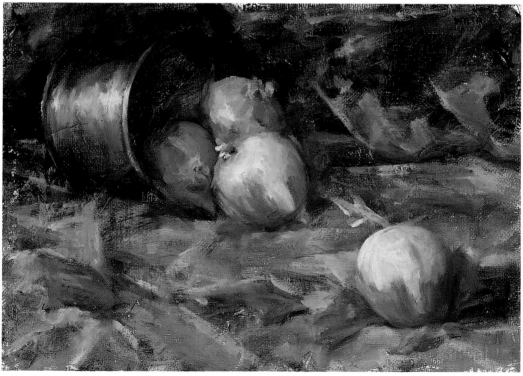

Onion Spill
11"x 16" (28cm x 40cm)

Grapes
10" x 16" (25cm x 40cm)

With her integral use of text and infinitely varied texture, Roberta Morgan updates the approach of the cubists, creating multi-layered pieces, part abstract, part representational, that allow the viewer to constantly discover new meanings.

Grapes

When I was in elementary school, my class took a field trip to a Byzantine Catholic church. After the priest talked with us about his branch of Catholicism, he celebrated the mass with us. In Byzantine Catholicism, the most sacred parts of the mass take place behind the iconostasis, which is opened for the congregation to see. It isn't easy to see though, because the line of sight is somewhat obscured by the iconostasis.

This removal from plain view is a way to emphasise the sacredness of the event taking place. This idea goes back as far as our oldest religious traditions. The Holy of Holies in the great Temple of Jerusalem comes to mind as a well-known early manifestation of the concept. There is even more happening here than that. This hindrance to plain sight is training for the eyes of faith. **Obscuring the view engages the power of the imagination.**

My paintings work in the same way. I give lots of visual information, but in a way that requires a little work on the part of the viewer. **The process of looking at my painting is not meant to be a smooth journey. I want it to be a process of discovery.** *Many of my paintings will not yield their secrets if you try to drill into them with your eyes. Instead, they open up as they hang in the hallway, next to a table, and you catch a glimpse of a newly discovered word or object as you hurry through the room.*

Paintings by Roberta Morgan have been exhibited in museums and galleries throughout the United States and as far afield as New Delhi and Stockholm. Morgan has worked as a curator in several venues. These include the Visual Arts Exhibitions for the Columbia Festival in 2000. She also curated Envelope, an exhibit at Rockville Arts Place, and was co-curator for The Watercolours of the Late Belisario Contreras for the Gaithersburg Arts Council. She has also written articles for local and national publications.

Morgan has received various awards and honours, including a grant from the Maryland State Arts Council. Her paintings were featured in the publication New American Paintings published by Open Studios Press.

delacroix — The source of genius is imagination alone, the refinement of the senses that sees what others do not see, or sees them differently.

We see with our eyes and also our minds. Anyone who has read a novel and then seen the film version knows that the power of our imaginative vision is fabulously stronger than mere physical sight. **When I painted 'Grapes', I knew that I had more to say than that I saw some grapes sitting on the table.** That is what I started with, my ordinary vision of some grapes on a napkin.

I have realised that it is more appropriate to call the sense of sight the senses of sight. Our brains call to action very different tools depending on the visual data that touches us. Looking at a representational image is neurologically different to reading text. Looking at an abstract image involves another process. At the same time, all of these processes are part of the inner machinery that processes visual data. When these processes go on to build visions of something that we have never seen, there is a creative act that is still tied to the experience of sight in a thousand undefined ways.

Antique Glass and Fruit
This is a painting about the new millennium; about old things and new things. It is a meditation on the idea that some things gain value over time, while others are best when they are fresh.

Flowers
Here I talk about hiding and revealing, and about the fact that what we understand is always coloured by what we have to see through to grab hold of that vision.

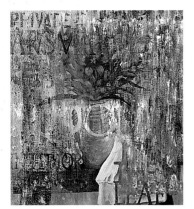

It isn't enough for me to show you the image of some grapes and fabric sitting on the table. It isn't enough for me to bring you through a process of seeing art that you have gone through a thousand times a week for as long as you can remember. It isn't enough for me to engage one part of your brain. I'm after a richer, more complex 'canvas'. I'm after the image that builds in the viewer's brain as he or she lives with one of my paintings.

I build a representational image, then I take some away by covering it with text. The viewer searches for meaning by trying to read the text, but that is blocked by abstract lumps, layers and streaks of colour. In the end, he or she has to re-assemble the things I am saying with my visual ideas as the image seductively gives hints of information over time. **As the text and textures of the top layers become familiar, the details underneath reveal themselves, making the viewer's interaction with the piece continually refreshing and unpredictable.** The result is that the painting is like a suitcase filled with ideas and meaning which you continue to unpack over many years of exploration.

acting

The representational image of grapes comes first. I find that the final painting rests heavily on the quality of this image, so I spend a lot of time with it. This time makes for a lot of thought that takes place like a conversation between me and my subject. What I try to find out in this interview with grapes, napkin, and table is the theme of the painting. I am discovering what the painting is about and what I am trying to say with it. Here it led me to the uses of grapes, to wine making, to a whole cultural tradition of the creation and enjoyment of wine. It doesn't end there. **I find that this is a painting about potential, about raw materials and the dream of possibilities.**

Starting with this train of thought, I put in the texts. **Text is tricky to work with in visual art because it is so powerful.** *I find that I have to be careful not to put in anything that shuts down the flow of ideas, or anything that may try to upstage the image that is already there. So I make the words clues to the meaning rather than an alternative path to meaning. Finally, I add the abstract webs of colour. This part is a real tightrope walk. It is easy to ruin a piece that has taken a lot of time to build to this point, so I have to be very careful. The care pays off, it emphasises some parts of the piece, and adjusts the flow of your eyes as they travel through the painting. The abstract elements can really make a painting sing.*

When they come together all these elements make a path toward the meaning I am communicating. So, my method of working is a process of discovering the meaning of the piece and learning how to communicate that meaning. When that mental picture compellingly engages the viewer's mind, my work is complete.

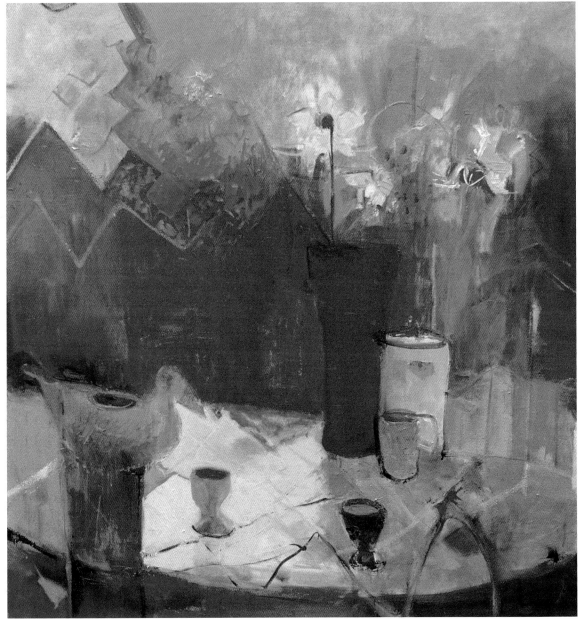

Nourishment is the only protection against the day's demands
40"x 40" (102cm x 102cm)

A simple breakfast table is transformed into a symphony of colour and texture. Teresa Pemberton creates an exciting physical surface, gouging out shapes with a palette knife, and varying the quality of the paint by applying it with the brush, knife, or direct from the tube.

"

*Nourishment is the only protection
against the day's demands*

*My inspiration for painting comes from a need to respond to
anything I hear, see or touch. I write down words from poems such as
those by Jenny Joseph, or novels such as 'God of Small Things' by
Arundati Roy, or 'Fugitive Pieces' by Anne Michaels. I jot down ideas
or thoughts I hear on the radio, or my own ponderings. In fact I
probably write in my sketchbook as much as I draw. I would never
wait until I had a fixed picture in mind before beginning a painting:
my paintings grow through many layers, many ideas, many
compositions.*

*You will notice that my paintings are actually a combination
of still life and landscape – landscape becomes a container for other
images. Jeanette Winterson said, 'Art is to find a space beyond the
everyday where imagination plays: aim to speak intimately, one to
one as well as on a grand scale.' I hold on to this idea. I pick up
connections and motifs as I work; not only connected to memories,
dreams, etc., but to myself, my position, what I am thinking about,
where I am; implying the possibility of change.* **I am interested in
textures, particularly woven materials and stitch marks,
and I like to incorporate stitch-like marks into the paint,
sometimes gouging them with a palette knife, sometimes
simply drawing them in, occasionally actually stitching
with needle and thread or wire.** *Stitches and textiles seem to
carry their past into the present.*

After a career spent in marketing for
the Folio Society publishers, Teresa
Pemberton spent five years on a Fine
Art Degree at the University of
Hertfordshire which resulted in 1996 in
a first class honours. She has exhibited
frequently since then primarily in
London, with two solo shows at
Moreton Contemporary Art in London.
She often shows her work in the
Buckenham Galleries, Southwold,
Cambridge Contemporary Art, and also
with Bishop Phillpotts Gallery in Truro,
Maltby Contemporary Art, Winchester,
and the CCA Galleries in London. Her
work is in many private collections
worldwide as well as in One Aldwych
Hotel, Strand, London; Champneys Hotel,
Tring; Hotel de Ville, Nanterre, Paris,
and Bushey Museum and Art Gallery.

Cézanne
Painting from nature is
not copying the object;
it is realising one's
sensation.

Pemberton's sketches of the sharply angled chimneys at Nerja inspired the dynamic concertina lines in the backdrop of the painting.

The background to a still life may be a memory of a place, usually a hot Mediterranean, a cool East Anglian or a Cornish coastline. I then use real objects which I draw directly on to the canvas or board. It is the combination of the two worlds of inside and outside that throws up the in-between, the unexpected delight of fresh surprises in paint. **I like the idea of juxtaposing contradictory elements in a painting;** elements which together make a third image which is therefore questioning or challenging where the painting or the emotion is. This began as a painting about daffodils. It was painted all over with a yellow wash and I drew daffodils bending various ways in two copper vases on a table. Later in the year I visited Nerja on the south Spanish coast and came back with strong hot colours in my head, and in an idle moment decided that the canvas needed hotting up!

During my stay in Spain I did plenty of sketches about the place, and some of the shapes stayed in my memory. For instance, the concertina lines came from the sharp angles created by the chimneys on many of the buildings I could see from my rooftop studio. I thought they added an interesting backcloth to a sunlit table which I intended to be for breakfast, hence the egg cups. I was intrigued by the different angles and shapes of the elipses in the egg cups, beakers, vases and jugs, and I played around with the positioning of these so that the spaces left were varied. **On to and into the oil paint I drew with oil pastel and oil bars to accentuate an edge or just to create a bit of interest on a surface, and of course the drawn zigzags in the front echo the 'mountains' behind and push the whole subject back creating depth.** The livid pinks, oranges and reds are really symbolic of heat and life. There are pale token daffodils remaining in the picture, which, along with the vertical pink zigzag on the top left-hand corner (a face?), give a slightly natural feel to the abstract painting.

Setting up still life objects on a table in the studio acts as a prompt for many paintings. Pemberton often gets an idea from a shadow shape or the way a line disappears from one edge and connects with another.

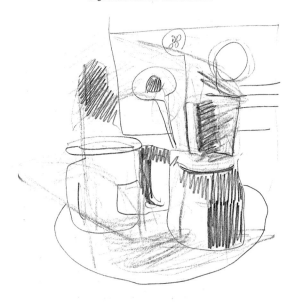

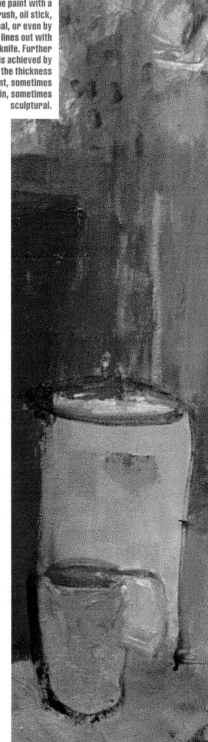

acting

*I paint mainly on canvas or cotton duck, but sometimes on small MDF boards, which need to be primed on both sides so that they do not bend. I also like painting on primed stout paper or card. You can prime this with button polish which gives a nice mid-tone brown. On to my canvas, after it is primed, I may slosh on a thinned down colour which may be the main colour of the composition, say red or blue. This gives something to work against up into the light tones and down into the darks. I love the tactile quality and slipperiness of oil paint and the fact that you can scrape it off and repaint as often as you like. Directly on to the canvas, I draw the main two or three lines of the composition, maybe a couple of horizontals and a vertical, then draw in one or two objects/shapes before applying paint. I incorporate the drawing into the paint, drawing with the paintbrush or with oil stick or charcoal, or gouging shapes with the palette knife. The paint thickness varies from very thin to a thickness as if squeezed from the tube. **A burying of things happens in my paintings as layers are built up. Some resurface. I like the painting to be not well wrought: not beautifully pristine and 'over' in the sense of finished. I like the idea that it has possibilities to be revisited.***

Pemberton's palette is very simple. She uses Spectrum oil paints:
Lemon Yellow
Spectrum Yellow
Cobalt Blue
Ultramarine Blue
Pthalo Blue
Spectrum Red
Crimson Alizarine
Raw Umber
Violet

Evening Stillness

Another parallel universe of inside and outside, this painting is again a coastal view with a group of objects which begin in reality on a tabletop, superimposed upon it. These blues and greens are very seductive colours and I had to break the blueness with bright pinks and oranges. In this painting I captured an idea of evening where many hues of blue are intermixed from the Cobalt, Ultramarine and Turquoise, all of them combined with Violet and then each other.

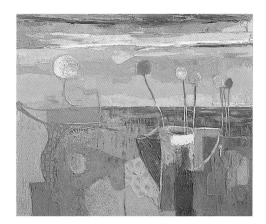

Blue Landscape

I am always looking at Cézanne's fruit, but rather than apples I love the slightly human form that pears possess and paint them often against a slightly odd background. This painting is against a dark landscape which I have used to create a kind of velvet feel to the flat pattern of the pots and pears. I wanted them to interact and speak to each other, within a slightly mysterious setting. The large pot was holding honesty flowers, which are a useful mid size of circular shape. This is repeated in the dotty pattern in the distance, hence creating depth.

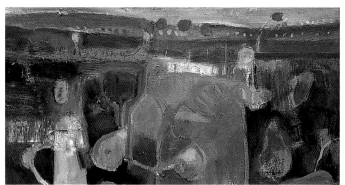

'Sea Through the Window' continues the theme of ambiguities – relationships between inside and out; spoons that are flowers. In all of Pemberton's multi-layered works, the viewer is left guessing. The eye is drawn into and around the picture space, to explore the wonderful depth of colour and varied textures.

> *Sea Through the Window*
> I noticed the jug of wooden spoons, whisks and other paraphernalia looked rather like a vase of flowers sitting on a window sill looking out to sea, so I imagined them as poppies or anemones, or both, and tried to keep them looking ambiguous to create interest.

I used my drawing to accentuate the stems or handles and one or two letters gave a certain dynamic to the jar to the left. Again there are many layers of paint here, but this time more Ochre-like earth colours in the foreground contrast with the fresh blue greens of the sea. One or two of the spoons are picked out in purer colours to accentuate the connection with the background and foreground. Whereas the 'Nourishment' objects are pushed back into space, here the jug and jar are right up front which I did by making the tone much darker and the objects larger so that the sea is in the distance.

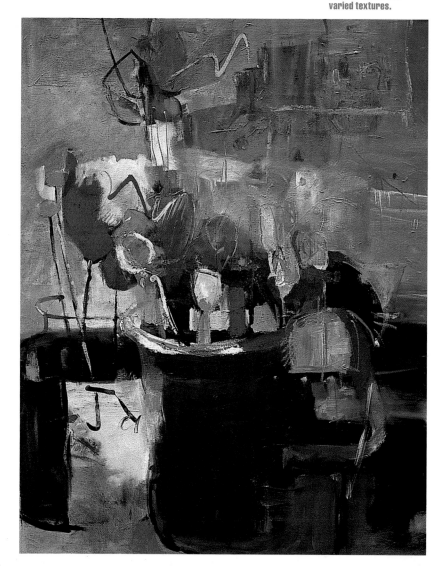

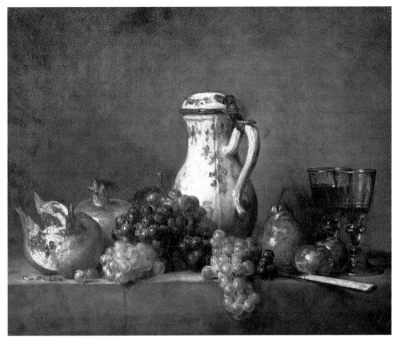

Still Life with Grapes and Pomegranates, 1763
by Jean-Baptiste Simeon Chardin (1699–1779)

Louvre, Paris, France
Peter Willi / Bridgeman Art Library

Still life can be quiet and reflective, but it can also exude life and energy. Particular combinations of colour, form and surface create very specific moods, immediately perceptible to the viewer. Still life, despite not containing any living feature, can tell us a great deal about the thoughts, mood and motivations of the artist. Colour can immediately suggest a dark or light frame of mind, whilst a composition can suggest openness, abundance, or social interaction, although it can equally give the impression of loneliness, squalor, or claustrophobia. Historically, the earliest Dutch works had a contemplative yet intense mood, focusing on universal questions such as the transience of life. Chardin's more domestic and intimate compositions, (although, arguably, still containing hidden meanings), had greater serenity – a coolness mirrored more starkly in the 20th century by the quiet thoughtful work of Giorgio Morandi, who has been a great influence on many contemporary still life painters.

Some still lifes tell stories through their manifest content and more cryptic symbolism. Doug Rugh's 'Final Rigging', for example, is laden with symbols which all come together to suggest the subconscious thoughts of a craftsman at work. The mangoes of Enriquillo Rodríguez Amiama are consciously conceived as visual metaphors for people. Through them he explores human interaction as the fruits seemingly communicate in contemplative surroundings or in larger groups.

Artists sometimes confess that painting still life is like a holiday compared with the more intimidating challenges of 'plein air' or portrait work, and as a result, the mood of the artist is often apparent. For Anna Metelyova it is an escape from the depressing gloom of early spring in the Urals, allowing her to indulge in a fantasy of the colour, fragrance and beauty of summer. The work of Karel Schmidtmayer, Rafael Saldarriaga and Philip Sutton is positively celebratory. Their compositions exude a sense of well-being.

Still life can be autobiographical – set up by the artist and frequently documenting their possessions and interests, it can contain important personal associations. Roberta Morgan describes her multi-layered, semi-autobiographical work as being 'like a suitcase filled with ideas and meaning which you continue to unpack over many years of exploration.'

Still life should never be considered mundane or of lesser importance to other subjects. It can be as challenging and innovative as we choose it to be. Across its history it has left an exciting document both literally and stylistically of the interests, lifestyles, and preoccupations of humanity, and, as can be seen here, it continues so to do.

Detail previous page:
Song for When Night Falls
by Enriquillo Rodríguez Amiama

Collection of Sharon Edwards

This joyous Matissian still life cascades across the canvas in glorious colour. Sutton's frequent references to his own, and his family's life, vibrantly combine the domestic with the monumental.

Claude's Still Life 1983
by Philip Sutton

Two mangoes communicate as if lovers against a dramatic, sparse backdrop.

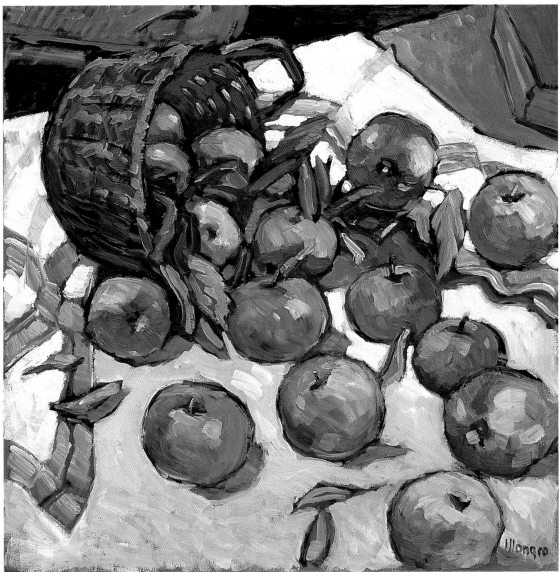

Basket of Apples
18"x 18" (46cm x 46cm)

Paintings of apples always conjure up Cézanne, but unlike Cézanne who carefully contrived his compositions, Rita Monaco prefers to simply 'discover' hers. Here she has captured the spontaneous arrangement of apples as they have spilt over from their basket, creating an image that is redolent of late summer.

" **Basket of Apples**
Still life is one of my favourite subjects. It expresses the essence of life, nature and, most of the time, hidden human presence. Its infinite variety of forms and colours lends itself to a wonderful vehicle for expression. **I rarely 'compose' still lifes. I prefer to 'find' them.**

Rita Monaco was born in Gioviano, a small village in the mountains of Garfagnana, Tuscany, at the end of the Second World War. Her Tuscan mother and Sicilian father took her to Sicily, when she was two years old where they settled in Trapani, the western most city of Sicily. Monaco started drawing at an early age encouraged by her architect father, and his mother, an accomplished impressionist landscape painter.

In 1967, she settled in Edmonton, Canada, where she enrolled in the Fine Arts Honours Programme at the University of Alberta majoring in painting and photography. This was followed by a 20-year career as a graphic artist and illustrator, before she became a full-time painter and art teacher in 1993. Since 1976, Monaco has been living in Vancouver. The variety in her subject matter reflects her eclectic personality and her many interests. She is a signature member of the Federation of Canadian Artists, and her works can be found in collections in Canada, France, Italy, Mexico, the United Kingdom and the United States.

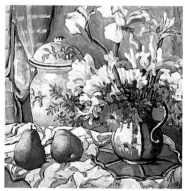

Still Life with Freesias
18"x 18" (46cm x 46cm)

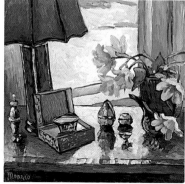

Maria Cristina's Tulips
18"x 18" (46cm x 46cm)

This still life just happened when the basket tilted from the weight of the apples and sent them rolling over the patio table. A warm October day, a dozen or so apples, and a blue and white kitchen towel are the main elements of this piece. **The image has a strong diagonal composition, which is perfect for a square canvas; my favourite shape.** *The straight lines of the towel and edge of the table counteract very effectively with the roundness of the apples and basket.*

In the sketches, Monaco wanted to get a feel for the composition and what had happened to the apples. With this understanding she was able to construct a strong and natural composition.

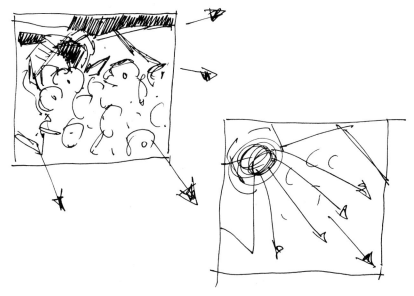

I wanted to convey the lingering warmth of the season, the weight of the apples and the crispness of the cloth. The apples were the last gift of the garden. They were blemished apples, offering themselves to me with all their scars and imperfections. **I set out to do a variety of pen sketches to get the feel of the image and study the composition.** *The second step was taking a few reference photos.*

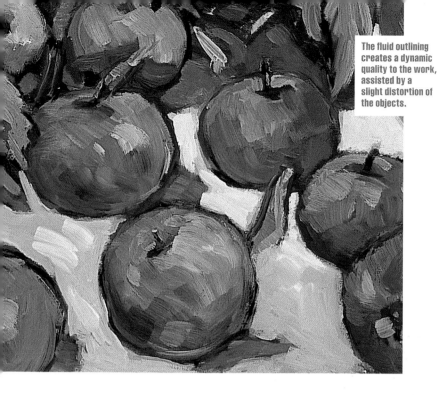

The fluid outlining creates a dynamic quality to the work, assisted by a slight distortion of the objects.

A very limited palette:
Black
Cadmium Red
Pthalo Blue
Cadmium Yellow
Pthalo Green

Occasional additions:
French Ultramarine
Quinacridone Violet

acting

The following day I began painting 'alla prima' on gesso-primed canvas tinted a medium blue-grey. I had to be quick before the light changed. **I drew the main shapes with black paint in a fast non-fussy way, trying to be accurate but also creating a bit of distortion that in my view lends a dynamic quality to the work.** *The main colours were then applied again with relative speed and directness. I use only Black, White, Cadmium Red, Pthalo Blue, Cadmium Yellow, and Pthalo Green. Sometimes I will also use French Ultramarine and Quinacridone Violet. Some colours are mixed on the palette, others directly on the canvas. I don't always use the same process – I prefer to get inspired by the subject.* **I rather not think about 'how' I am going to paint. Instead I have a final vision of the piece in mind and endeavour to get close to this vision.** *I wanted to portray the feeling of the piece as much as the physical features. This painting evolved with no problems until I had to stop because of lack of light. It was finished the following day with the help of memory, experience, and a few reference photos.*

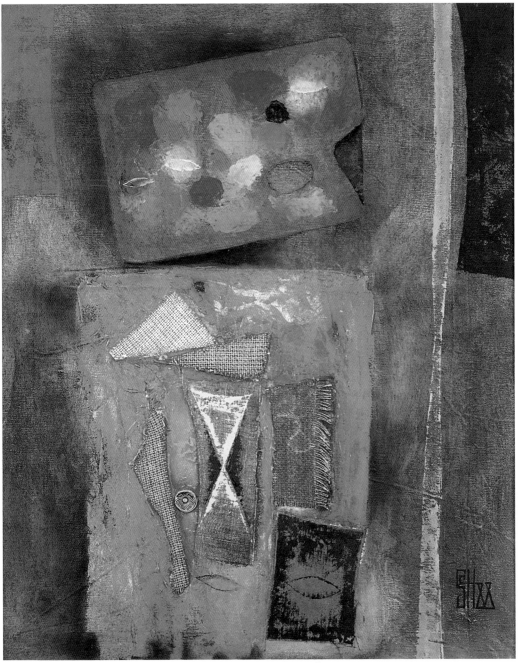

Through a combination of rich colour, texture, and a deeply reflective approach, Karel Schmidtmayer produces work that is full of atmosphere and symbolism and that speaks volumes about his relationship to painting and the environment.

The scale and angle of the palette reinforce the upbeat mood of Schmidtmayer, revelling in the fact that he can and does paint. The palette's angle also serves to emphasise the stillness of everything else in the painting.

Eyes of Colours
29"x 24" (74cm x 60cm)

Eyes of Colours

My early influences included my countryman, Kupka, and the circular gyrations found in his synchronistic paintings, and there are also echoes of Delaunay's Orphism. As time has gone on, **I have become more fascinated with decoration, texture and rhythm, and with the introduction of gold or bronze my work is more linked to that of Klimt and Klee.** *However, the closest parallel to my art might be drawn from Art Informel and the free abstraction which flourished in 1950s' France.*

The distinctive art of Karel Schmidtmayer includes still life and landscape, and is frequently based upon his philosophy of the disharmony between man and nature and the latter's intrinsic power to rid itself of impurities inflicted by the former. Born in Northern Bohemia in 1949, he was surrounded by the Dantesque evidence of this gargantuan struggle for supremacy. The deep scars are evident in some of Schmidtmayer's early work. He was taught by the renowned Czech abstract master Selbicky at Usti nad/Labem and developed his individual style of abstraction in the comparative isolation enforced by the Communist censors. This seclusion has produced works of remarkable depth and intensity, with a powerfully moving undercurrent of colour and emotions.

The surface of the painting, already heavily textured through use of the palette knife, is made more interesting with the addition of frayed cuttings of jute.

With this picture I have attempted to convey the idea that the moments spent painting are a holiday for me. It emanates my celebratory mood. **My works are multi-layered and evolve only gradually.** I don't start with a defined shape, but rather have a central scheme upon which the structure will rest.

Here the gaiety of the painter's palette shines like the sun. All the ordinary items on the table below are transformed into romantic articles. **The subtle plume of cigarette smoke is reminding us how truly transient these moments really are.** The slightly tilted palette emphasises the stillness of everything else. I tend not to work simply with paint, but introduce colourful patches of texture, pieces of material, or the imprints of perfectly formed, man-made objects in order to compliment the artistic message of the image.

The smooth paint contrasts with areas of colourful impasto and an assemblage of irregular pieces of jute, which are partly frayed to the right. All the angled shapes are tempered by the small circular imprints of filigrans, central European decorative love tokens or amulets, given to mothers and lovers by the men folk when called to battle. The shapes and colours are complimented by the repeated symbol of an eye.

The picture is painted in epoxy-oil and classic oil paints, but in several places there is a deposit of bronze pigment. These glazed bronze areas are painted by brush, whilst the impasto areas are created by palette knife. There is also an interesting 'wrinkled' effect created by crumpling the canvas and applying strands of artificial fibres.

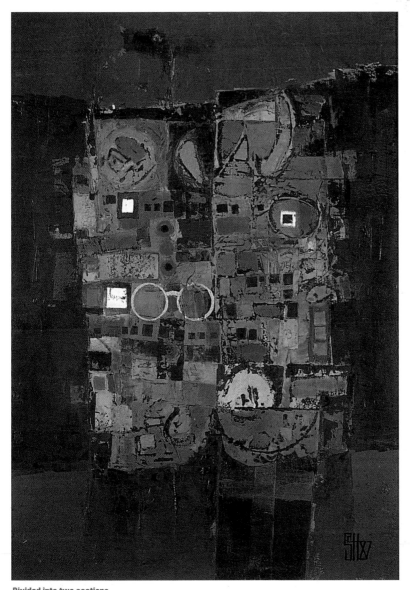

The Pink Glasses
This painting was conceived and produced as an indelible impression of meeting with a friend, who is an incorrigible optimist. His stoical analysis of life's eventualities have released me from the shackles of scepticism many, many times. The picture represents a sectional glance at the fabulous mosaic of life.

The painting is divided by a vertical axis into two almost equal parts, through which there are several strands of combinations of black squares. These squares symbolise an imaginary dialogue. The other geometrical shapes help to balance the space visually. The lucid, classic shape of the spectacles represents the abiding philosophy of my friend – the idea of 'looking at the world through rose-tinted glasses', from which I have created the title of the work. Overall, the colours used are subordinate to the concept, but in line with the theme, I have kept a predominance of warm shades.

Working on canvas, I built up the painting in layers with a touch of enamel as a base. In places I applied a layer of varnish which gave it a sheen, and slightly modified the colour. By using a palette knife, I created a textural effect that gives it a slightly 'distressed' effect, which is especially noticeable on the colourful flat surfaces.

Divided into two sections, 'The Pink Glasses' uses a mosaic effect to represent the interplay of a conversation. Similarly Klimt divides his image of communion into male and female – square shapes representing the male, and ovals defining the female. Schmidtmayer has been inspired by the rhythms ever present in Klimt's work, and his inclusion of metallic highlights.

Fulfilment (Stoclet Frieze) c.1905 – 09
by Gustav Klimt (1862 –1918)

Osterreichische Galerie, Vienna, Austria
Bridgeman Art Library

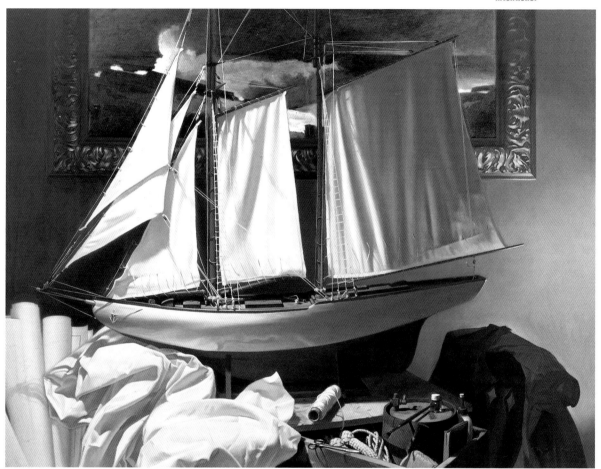

Final Rigging
36"x 48" (91cm x 122cm)

Doug Rugh

Final Rigging

I design my paintings so that they'll work in all types of light. **The painting then becomes a living thing designed to be viewed under different situations just as sculpture appears different as the light of the day changes.** *For example, in a low-light situation the values and the hues in the light range may become the important colour and contrast elements while the same painting under bright light may reveal highly saturated colours in the dark values which may then take over and become the prominent elements in the composition.*

Doug Rugh spent his childhood in the Middle East where his father was an American diplomat and his mother was an anthropologist. As a teenager he was apprenticed to artisans in Cairo, Egypt and was involved with the arts at the Putney School in Vermont. From there he went on to study at the Maryland Institute College of Art with Will Wilson and Anne Schuler at the Schuler School of Fine Arts, an atelier which specialises in materials and methods of the old masters. He completed his Bachelor of Fine Art at the Rhode Island School of Design with honours. Rugh has been commissioned to create art for such clients as Barnes and Noble, Microsoft, The New York Times, Reader's Digest, Newsweek and The Washington Post. Commissioned work appeared regularly on book and magazine covers as well as in numerous publications. Rugh now devotes all of his time to creating oil paintings for galleries. His work can be seen at Tree's Place in Orleans, MA and the John Pence Gallery in San Francisco, CA.

Navigating the Tides
16"x 20" (40cm x 50cm)

I first saw this model boat when visiting the collection at the Massachusetts Maritime Academy and was struck by its home-made character. Right away, it brought to mind the model-maker carefully completing his special project. I imagined him indoors under a warm light and yet dreaming about adventures on the high seas.

As an artist I also spend much of my time indoors working on my projects and before I know it I realise time has passed and I've been absorbed in another world. **This painting represents the inner world of the imagination of the craftsperson.**

The main thrust of the composition was created by arranging the light values in animated patterns. *Though stationary, the boat seems to forge steadily ahead against the surging waves of the sailcloth. The dynamic shape of the cloth holds the excitement of the waves upon the sea. The light falls across the front of the sails and then ripples towards the stern in a rhythmic movement echoed in the repetition of the charts (or are they model plans?) to the folds of the sailcloth on the table, and then back up through the rigging and the forward sails.* **The movement ends with a quiet crescendo of the wave, not noticed at first, in part of a painting by Winslow Homer called 'Weatherbeaten' on the wall behind.** *Light bounces against the shiny surface of the bow as it slides through the 'water' and the silhouette of the raincoat on the chair continues the movement of the trailing wake that follows behind.*

Moving on from the brightly lit areas of the painting, the darker values operate on a secondary level representing the more mysterious and unknown aspects of adventure. **The backlit diamond shapes in the chair become eyes in a world in which objects take on a life of their own.** *The framed picture becomes the fantasy of the boat or the artisan, and at the right all is seen of Homer's signature is 'mer' for the sea. The ornate gold frame represents the ideals of our dreams and as a compositional device allows the eye to move out and back into the painting.*

I initially block in my paintings with tube paints but use hand-mulled paints to do most of the rendering and to manipulate various glaze effects. I try to use as little medium as possible by selecting tube paints that are at the right consistency for the given situation. For example, **with a large painting I'll start with more fluid paints and for a small panel painting I'll choose the stiffest most heavily pigmented paints possible so that I can go to direct modelling without being 'lost in the soup'.** *Once I have relative colours established I'll grind up handmade paints to a very stiff consistency. This way I can achieve nuances of chiaroscuro through modelling and delicate temperature shifts with transparent glazes or opaque scumbles. I don't work from photos because the camera can't quite capture the subtle shifts in temperature and the wide latitude of values visible to the eye. I also don't want anything to get in the way of seeing.*

> Since this is a large piece I tried to organise the composition so that it would hold up on a small scale because the painting can be viewed from a distance. At the same time on close inspection the picture will have details that provide new surprises. The ornate frame, for example, on close examination becomes a patchwork of abstract shapes that locks into the representational illusion from farther away.

In the lower right corner are the 'real world' objects that the model-maker uses in his craft bringing the painting into contemporary times. This area works as a still life in its own right.

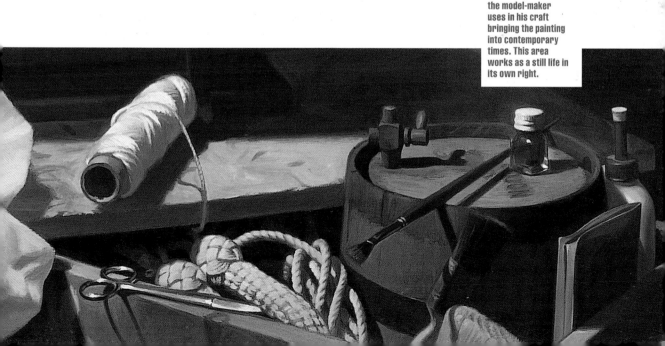

Digger's Salvage

There is a salvage yard near me that is in a dark old warehouse and it's a source of enjoyment to browse amongst the interesting antiques and old ornamental pieces that are stacked up in the shadows. In 'Digger's Salvage' I wanted to create a feeling of antiquity and history by referencing music, art and architecture. I love the richness of the deep black organ pedals where you can just make out some of the carved detailing in the catch-lights. The pink carved wooden column pieces have a beautiful grey dust that has settled in the spirals. The light illuminates the sculpture, which I think of as the muse, where the shadows and the dust can't obscure the beauty and depth of handmade objects. The raking light on the carpet is a homage to Vermeer – one of my favourites.

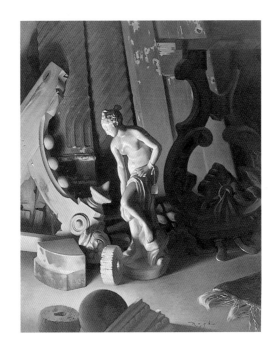

Bones of the Sea

I liked 'Bones of the Sea' from the first sketchy layout. I started with a very saturated Pthalo Green underpainting because I wanted the underlying feeling of that pure but mysterious sea colour to predominate. I contrasted that main colour idea by adding the warmth of the crate. I especially like the way a low angled light wraps its shadows around forms and the smooth brass timepiece sets up the contrasting textures. You can feel the translucency of the whale tooth by the redness in the hollow and the light that skims across the powder horn reveals the transparent layers of bone. The blue highlight on the lantern is the beacon that is reflected off the ripples of the glass and, what is so important to the sailor, the sturdiness of the rope whirls around out of the background. These were all objects that I took great pleasure in painting.

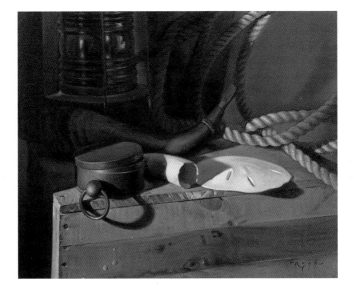

Rugh uses the same palette for just about everything including landscapes and portraiture. He can mix any colour he needs from it, although he varies it if he wants to add transparent qualities rather than just painting opaquely. Sometimes he also varies the pigments to utilise their specific chemical properties.

THE MULLING PROCESS

Hand-mulling pigments allows the artist to determine the consistency of the paint. Tube paints, particularly when thinned, can be very fluid which is useful to cover large areas. Mulled by hand a coarser texture can be created which, if used with minimal medium, gives a stiffer consistency that can be used to model rather than simply to paint.

Cadmium Yellow Medium (warm)
Cadmium Red Medium
Quindo or Perylene Maroon
(Alizarine substitute)
Ultramarine Blue
Pthalo Blue

The purity of the rose,
combined with the
horizontal format
creates a serene image.
With the rose playing the
dominant role in the
composition, white
unicorns are almost
hidden deep in the picture
space. Together they
speak of Metelyova's
desire to escape from the
gloom and coldness of her
urban environment.

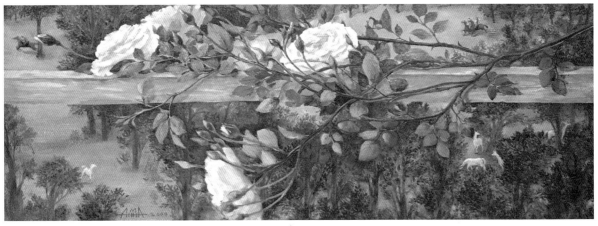

Sub Roza
14"x 33" (35cm x 85cm)

Sub Roza

It was spring – not the most pleasant time in the city. There was melting, dirty snow in the streets from the morning's fall which had by evening turned to rain. In general, the Urals are a severe region, but especially so in spring. I was so tired after the long winter. After the cold and darkness, I wanted summer to come immediately but we had to wait for it two months more. It was too long!

Anna Metelyova was born in 1963 in Leningrad (presently St Petersburg). She graduated from the Yekaterinburg Art School in 1982, and started participating in exhibitions in 1983. She graduated from the Department of Graphics at the Repin Institute of Art, Sculpture and Architecture in St Petersburg. She joined the Union of Artists of Russia in 1993. At present she works as a graphic artist and as a painter. Her varied and intriguing works are exhibited in museums and private collections in Russia and Europe.

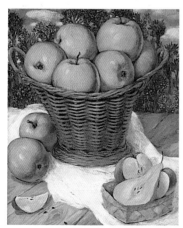

Full Basket
22"x 18" (56cm x 46cm)

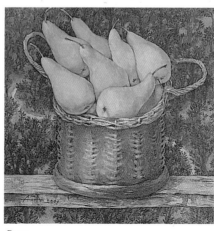

Pears
19"x 19" (48cm x 48cm)

Most people only see white horses, but they are actually unicorns, symbols of the secrecy and mystery of Metelyova's private world.

At that time I was working on an exhibition – the date had been already fixed and as usual, I was running out of time; but the desire to escape out of this city's gloom was stronger than tiredness. **I took a canvas destined for another picture and began my fragmented escape out of reality.** I say fragmented because I had to grab the opportunity to paint during my work breaks. I didn't devise a plot. I saw it in my head when I was walking along the wet street trying to breathe less frequently to avoid the exhaust fumes, and trying not to listen to the cacophony of automobile honks on the crossroads. Instead – thick hedgerows, green meadows, the fresh and expressive fragrance of flowers, and grass heated by the sun – that's where I imagined myself, and I began to paint just these things when I came to my studio. I literally felt the fragrance of a rose and **it was so great – to escape for a while into my secret, personal world.**

I was painting that rose as a symbol. I always remembered the novel by Umberto Eco, where a rose stood as a symbol of a secret and mystery. The words Sub Roza mean 'under a rose' like a finger put on one's lips; 'Hush, don't tell anybody about what you have seen or heard, it's a secret.' **And so it turns out, in my painting most people only see a luxury rose** and don't notice that the white horses among the trees are, in fact, unicorns, thus meaning that my secret land is hidden from the audience, even though I painted it in detail.

 The horizontal form stresses the sensation of rest, and gives the effect of a panorama to the picture even though in reality it is just a fragment of scenery. The rose's bough is 'above' – above the trees, people and animals. The level on which it lies isn't separate, it unites all the details around itself. The colour, as you see, is very reserved. There are no red, or blue, or yellow areas, only light Ochre, just a bit of pink, and a lot of green hues. Nothing grey or black.

 In general, it was my protest against urbanism! That is a story of 'Sub Roza', hush...

When I have an idea for a canvas, I make a small sketch of it in soft pencil so as not to forget what I've been thinking about. Sometimes ideas spring up one after the other, and I can make five to ten of these scribble-sketches on one sheet of plain writing paper. I never throw them away, even if the canvas has been already finished, just in case I happen to make something else out of it in the future. I never make any detailed sketches in colour, because this kills the desire to make a big canvas or painting, and because I start feeling bored. Whether I work on primed or unprimed canvases depends on the mood and the kind of texture I plan to use in a painting. If the canvas has no primer I paste it with a layer of gelatin and apply a coating of two or three layers of oil on top, then I apply a layer of Zinc White and wait until it dries.

Rather than using thick brush strokes, as I used to, **I now mainly work in small transparent strokes or glazes. I like the fact that this way the painting acquires a kind of luminous warm light.** On the prepared canvas I make a sketch in Ochre. The Ochre has to be very liquid and I use a soft wide brush. I may make quite a mess on the canvas. I rub off what I don't like using a rag, and then work on it until I'm satisfied with the composition. As soon as this happens I start introducing colour. Usually the initial period lasts one to two days. Then I put the canvas away for several days to dry. Meanwhile I work on other canvases. In my workshop there are always some ten other paintings in different stages of work, it's a continuous process.

Like the unicorns the rose is a symbol of secrecy and mystery. It also serves as a symbol of purity amidst the grime and pollution of urbanisation.

With exuberant flowers set against the backdrop of the city, Rafael Saldarriaga sums up his excitement of setting up his studio in New York. They cascade over the vase, mimicking his emotions and stylishly bringing nature to the urban panorama beyond.

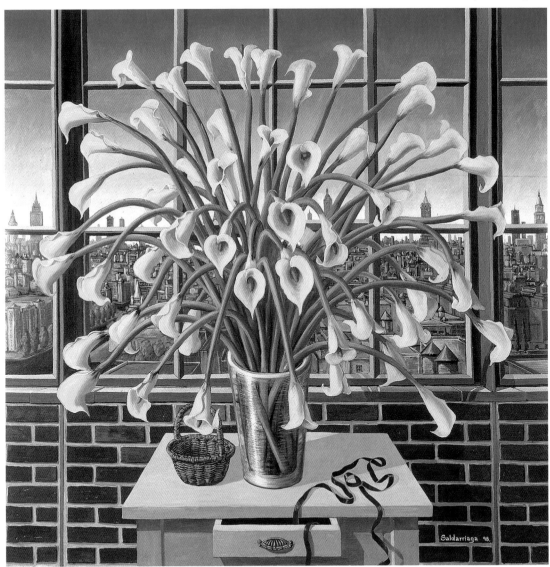

Flores en la Ventana
78" x 80" (198cm x 203cm)

Flores en la Ventana

*When I paint, my desire is to create something nice for the spectator. I use festive colours – tropical colours – with a lot of light. When I paint, the model is in my memory, rather than painted from life. For example, when I paint a flower, I interpret the memory I have of the flower. In the process **I am loyal to my feelings and not to reality.***

Rafael Saldarriaga was born in Medellin, Colombia in 1955, and arrived in the United States in 1993 after living in New Mexico and Hawaii. He is now resident in New York City.

Saldarriaga studied in Live de Zulateqi's Art Academy and also graduated from the school of Architecture and Urban Design with Pontificia Bolivariana University. In 1984 he became a full-time painter. He developed his distinctive, cool style from Classical and Creole elements. The combination of still life with panoramic landscapes behind creates a spacious, quiet atmosphere, almost detached from reality, using oranges and other fruits, tables, baskets, landscapes, flowers and festive colours among other elements to express the special flavour of his creations.

Saldarriaga uses images from everyday events to connect simple elements of life with the universal. His harmonic work exudes his appreciation of aesthetics, perfectly blending the natural and the man-made. His work extols the fecundity and sensuousness of an abundant and luscious harvest; the feminine; the concept of life; the container and its content; the representation of the voluptuous; the sensual and the erotic; colour and form.

La Ventana de Viento
58"x 56" (147cm x 142cm)

La Mesa de las Ciruelas
54"x 54" (137cm x 137cm)

This painting includes the view from my studio in New York. It is not a literal or photographic view. It was actually the first painting I did in this studio, and I was feeling very comfortable and happy, so, it is like an explosion – like fireworks. I was also drawn to this subject through the way that it brought nature to the city. **I was interested in the contrast between the nature of the flowers and the nature of the city beyond,** and I wanted to magnify the multitude of blooms, inviting the spectator to contemplate them through my painting. I very much like lilies, they are so elegant and beautiful. Somehow they are a universal subject – you can find them everywhere.

When painting my still lifes, I follow three steps. First, I have an 'intuition' for the painting. Taking a No 7 round brush I make a 'stain' on the canvas trying to capture my vision exactly, in every detail. For this I use the mix of all the colours that are left on my palette when I clean it up. The colour is something between grey, brown and green, and it is like painting in monochrome. This comes directly from my imagination, and how I remember things – the landscape, the oranges, etc. I don't usually do sketches, although occasionally for the big paintings I will do a few small ones (15cm x 15cm) to gain more formal control. Normally, though, **I come directly to the canvas and visualise what I have in my mind. I plan it out mentally, learning each of the elements and the structure by heart.** I don't set up a still life to work from. My canvases are usually square, with a circular composition within, and from 1m to 2m in size. I always have the light source coming in from the left.

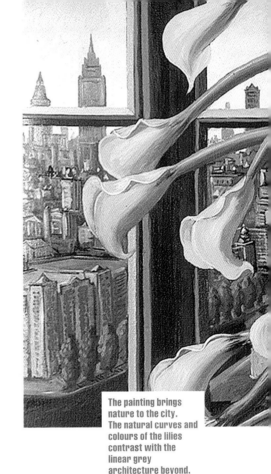

The painting brings nature to the city. The natural curves and colours of the lilies contrast with the linear grey architecture beyond.

wesley pulk

From a distance Saldarriaga's work looks almost photographic, yet up close one discovers exuberant and freely painted brushwork that seems casual.

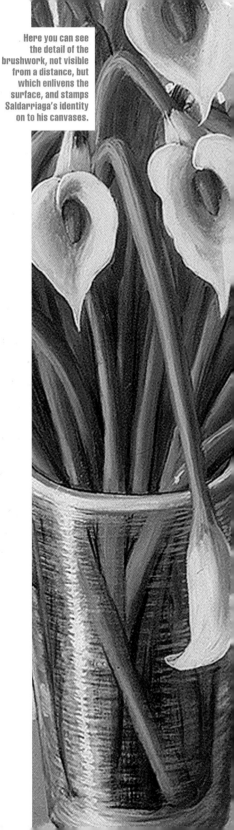

Here you can see the detail of the brushwork, not visible from a distance, but which enlivens the surface, and stamps Saldarriaga's identity on to his canvases.

acting

In the second stage of the process I find the right colours and the values of light and shadows, and then develop the texture, together creating the perfect relationship between shapes and space. This stage is where I give life to the picture or, as I call it, I 'inspire' the picture. Everything is very spontaneous, the colours, the composition – **everything goes down as a response to my emotions.** I work until I achieve what I was aiming for – soft light and a feeling of balance.

The third stage is the moment when I decide to stop work on a painting. This is the moment of unity, harmony, acceptance, and peace between myself and the painting. But a painting is never finished. Usually I want more, but I can be at peace with what I have achieved. It is okay for the moment.

From a distance my paintings look photographic, but when you come close you will see that this is not the case. I don't try to compete with a photograph, I just try to recreate what I see, or how I see it. The results are more important to me than the theme itself. People describe my paintings as post-modern, neo-classical, realist or even surrealist. I choose universal pictorial elements. These elements become mine like the writer with the words.

glossary

The artist's trademark –
a beautiful traditional
wooden palette,
emblazoned with areas of
thick rich paint. Although
many artists do use these
kidney-shaped palettes,
they can be heavy. You
can also purchase
smaller oblong ones
designed to fit in painting
boxes, or even
disposable oil-proof
paper ones, bound into
pads. Many painters use
materials to hand such as
pieces of hardboard or
slabs of melamine.

Oil paint consists of ground pigment suspended in an oil such as linseed, safflower or poppy. Whilst liquid, it is soluble in solvents such as turpentine or white spirit, but once dry it's insoluble. Whereas water-based paints such as acrylic and watercolour dry very fast as the water evaporates, oil paints take up to a year as the oils combine with the oxygen in the air and solidify. Artists can buy the raw pigments and grind and mix them themselves, but most prefer the convenience of ready-prepared paint in tubes. Oil paints are sold in two varieties, artists' and students' colours.

artists' colours

Artists' colours are high quality paints made from the finest pigments ground with the minimum of oil. They have a firmer consistency and use purer pigments in higher concentrations than in the students' variety, and therefore offer greater strength of colour. There is also a wider range of colours.

students' colours

Students' colours are cheaper because they contain less pure pigment and more fillers and extenders. They are great for beginners to experiment with, and dry slightly more quickly than the artists' variety. However, the colour range is relatively limited and they do not produce such vibrant results.

water-mixable oil paint

Water-mixable oil paint has become more readily available in recent years. Thinned with water, it dries more quickly and is less messy to use and clean up afterwards. Artists allergic to solvents find it particularly useful.

Acrylic paint is a flexible water-based paint that can be used in the same way as oil paint, producing equally textured and vibrant paintings. Because it dries quickly, however, it is not possible to move the paint around as much as you can with oils. It will be noted that some artists use acrylic for priming and underpainting because it will dry in less than half an hour. Oil paint and glazes can be laid over acrylic but it must be remembered that acrylic cannot be laid over oil.

Although oil paint can be used directly from the tube it usually needs to be diluted to allow it to flow more easily on to the support. Dilutents are also for cleaning up the brushes and palettes – and your hands!

Turpentine, made from distilled resin from pine trees, speeds up the drying time of the oils. Household turpentine is not suitable – you will need to purchase the double-distilled variety from art supplies stores. Care must be taken not to expose it to light or the air or it will quickly deteriorate.

White spirit, distilled from crude petroleum oils, is a cheaper, if more pungent, alternative. It has the advantage that it dries more quickly than turpentine and doesn't deteriorate with age.

bristle

Bristle brushes are particularly suitable for oil due to their springy, tough quality. Hog's-hair brushes are the most popular since they can hold a lot of paint. Bristle brushes can move paint about effectively, and can create chunky dabs of colour.

synthetic bristle

This is the choice of those who wish to use non-organic brushes. Synthetics are also more economical to buy and many are of very high quality. They tend to be softer than true bristle.

sable

Unlike in watercolour painting where sable brushes are the choice of professionals, they are rather soft for oil painting. They are, however, useful for adding detail or applying thinly diluted colour.

brush shapes

Rounds with their long thin bristles are the most useful shaped brush since in addition to being able to cover large areas of a painting quickly, they are also good for sketching.

Flats are square-ended brushes and are suitable for applying thick, bold colour if used flat, or for fine lines if used end on.

Brights are the same shape as flats but have shorter, stiffer bristles. These are useful for applying paint thickly and creating impasto textures.

Filberts are also similar to flats, but the bristles curve slightly inward at the end, allowing them to produced tapered strokes.

Fan-shaped blenders are for blending and can create very smooth, highly finished effects.

painting knives

Painting knives have very flexible blades made of forged steel, and cranked handles. They look like miniature trowels. Made in a variety of shapes and sizes they can be used instead of brushes where they create an expressive surface texture, laying the paint on in flat smooth planes with ridges where the stroke ends. Not only can they lay paint, but they can also be used to move it around and scrape it off, or even used to scratch in detail.

palette knives

Palette knives have a long, flexible blade with a rounded end and are intended for mixing on the palette and cleaning up.

Brushes, from
top to bottom:
Sable
Flat
Synthetic filbert
Bristle flat
Bristle filbert
Synthetic round
Sable fan blender

The support is the material on which the painting is made. For oil paint, it is important that it doesn't absorb the oils in the paint. Whilst a great variety of materials can be used, only the most common are discussed below.

canvas

Canvas is the most popular surface for oil painters – it is very responsive and has a good texture (or 'tooth') to hold the paint. It can be bought ready stretched and primed on wooden stretchers, pasted on to stiff board, or off the roll for you to stretch yourself. The weight is measured in ounces per square yard, and the heavier it is, the higher the density of the weave, and therefore the better the quality. Textures come in fine, medium or coarse-grained varieties. There are two types of canvas – cotton and linen. Linen is the best because it has a fine, even grain, and is, predictably, more expensive.

board

Board is a cheaper option than canvas. Apart from ready-prepared canvas boards, you can also buy hardboard, plywood, MDF or chipboard which can either be sized with rabbit-skin glue or PVA, and/or primed.

priming

Supports need to be sealed (or primed) before being used otherwise the oil will seep down into the canvas leaving the paint brittle and likely to flake. Today many artists use a fast drying acrylic primer which does away with the need for a traditional glue size. Size is a gelatinous solution such as rabbit-skin glue or bone glue which is used to seal the support. It is much cheaper if you prepare this yourself.

Oil-based Lead White is an excellent primer since it will stretch and contract with the canvas as the atmosphere changes. If hardboard is used, a much cheaper option is to use quality household matt white emulsion after the surface has been sanded to give it a tooth. Two or three coats should be applied, with each being painted at right angles to the one before, after each has fully dried.

The ground, or primed surface, of any support provides a sympathetic surface to begin painting on.

coloured grounds

Whilst some artists like to work on a pure white surface that reflects light through the paint creating a luminous quality, many feel intimidated by the prospect of a bare white canvas. Colours look too dark against it, resulting in a tendency to paint colours too light. A mid-tone allows the colours to be judged more accurately and worked up or down accordingly. Some artists choose to work on a dark ground, causing them to use lighter colours. The coloured ground is applied as a thin layer of paint diluted with white spirit, over white priming. Any colour can be used, but normally a neutral colour is chosen.

Many artists use colour instinctively, but this is usually based on years of experience and a thorough understanding of colour theory and mixing. The essentials are not difficult to understand.

the colour wheel

The colour wheel is the artist's basic and perhaps most important tool. It consists of the principal colours of the spectrum, pulled round into a circle. Each of the three primary colours, (red, yellow and blue), are separated by the secondary colours (orange, green, and purple). Such an arrangement allows the artist or designer to appreciate the relationships between colours and see how they will work with one another.

primary colours

A primary colour (red, yellow or blue) is a colour that cannot be made by mixing other colours.

secondary colours

A secondary colour is made by mixing two of the three primaries.

tertiary colours

Tertiary colours are produced by mixing two colours that are next to each other on the colour wheel, e.g. red and orange to produce a red-orange, or yellow and green to produce a yellow-green.

complementary colours

Complementary colours lie opposite each other on the colour wheel, and, if placed together, create the most vibrant and discordant contrast: red-green; blue-orange; yellow-purple. When complementary colours are mixed together they create neutral greys and browns.

In theory, any colour imaginable can be mixed from the three primaries, but in practice, you will find that you still need to purchase other colours. This is due to the fact that paint pigments are not 'pure' and each variant of a colour will have a different colour temperature.

colour temperature

We don't need to know about colour theory to have a basic understanding of colour temperature. All of us already have associations through life experience. Reds and oranges remind us of fire or sunshine, and suggest warmth. Blues are cool colours, associated with water. We also make more subtle judgments such as recognising that some people have cool skin tones, whilst others have warm tones. It is this subtlety that is important to understand in colour mixing. In landscape paintings a harmonic colour scheme tends to present itself naturally, for example in a sunset where all the colours tend to be warm, or in an early morning winter scene where blue tints are dominant. With still life though, we choose the objects ourselves and need to be aware of the harmonies, perhaps limiting the scheme. In paintings with a more varied colour scheme warm colours will come forward in a composition, whereas cool colours will recede. If this is not properly handled, the composition will fall apart.

From left to right:
Glazing
Optical mixing
Scumbling
Sgrafitto
Imprinting

palettes

The traditional palette is the kidney-shaped wooden variety with a thumb-hole, but you can also purchase oblong ones designed to fit in painting boxes, or even disposable oil-proof paper ones, bound into pads. With traditional palettes it is a good idea to plan how you will lay out your colours so that you can find them easily and ultimately automatically.

It is not necessary to buy a commercial palette. Many artists simply use a piece of non-porous material that they have lying around their studio – a piece of hardboard or melamine for instance.

dippers

These are small metal cups that can clip on to the edge of a palette, designed for holding oils and thinners.

varnish

Varnish is a resin dissolved in a solvent. It is used not only to protect paintings from physical and atmospheric damage but also as a glazing medium, adding depth to the colours. Dammar and mastic varnish dry to a high gloss although they are not entirely stable. Synthetic substitutes tend to perform more reliably. Varnishing cannot take place until the oil painting is completely dry, which can take up to a year.

techniques

painting fat over lean

Painting 'fat over lean' is one of the key things artists need to consider when painting in oils. Paint that has a high oil content is described as 'fat', whereas that which has been thinned with turpentine or white spirit is known as 'lean'. Lean paint will dry more quickly than fat, and as the oil oxidises and the paint dries, it shrinks a little. If there is a lean layer on top, it is likely to crack and flake off as it hardens. For a painting to be durable, successive layers should be built up with increasing oil content. Colours have different oil content; Payne's Grey and Burnt Umber are naturally rich in oil, whereas Flake White, Terre Verte, Lemon Yellow and Cobalt Blue are lean.

under-painting

Traditionally, oil paintings were developed from a detailed monochrome under-painting. Although some painters still follow this method as we have seen in the work of Juana Cañas, it is more common today to begin with a more informal under-painting that simply indicates the main elements and forms of the composition. This might be done in thin colour to assist in the overall conception of the image, or it might become an integral part of the final painting, providing a casual, sketchy feel to the composition.

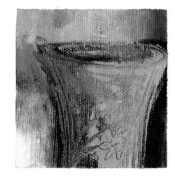

blending

Because oil paint dries so slowly it can be manipulated like no other medium. Colours can be blended whilst wet to produce fantastically smooth gradations that can create the illusion of all kinds of materials – glass, velvet, skin, metal, etc. The Dutch still life painters of the 17th century were masters of the craft, blending colours so smoothly that the brush strokes were invisible. Blending can also be achieved by dragging one colour over the edge of another, creating a rougher, lively colour mix.

impasto

This is the term given to paint that has been applied so thickly that you can see the brush strokes or ridges left by a palette knife. It gives the painting a chunky, three-dimensional effect and has been used by many of the greatest artists, notably Van Gogh and the German expressionists, when it becomes almost sculptural.

glazing

A glaze is a thin layer of paint applied over dry paint, allowing the base colour to show through. This can be repeated again and again, resulting in wonderfully luminous effects. Thickly applied paint is often used in conjunction with glazing. A dark glaze over a light impasto will adhere to the grooves emphasising the brushwork. This can be useful for textures such as rough wood or mossy stone.

optical mixing/broken colour

Optical mixing was the discovery of the impressionists and immediately enlivened their canvases. Optical mixing means that the colour is mixed in the viewer's eye rather than on the palette before it is applied. If, for example, dabs of yellow and red paint are applied close together, from a distance the area will appear orange. Furthermore, this orange will seem much more interesting than a simple slab of premixed colour.

sgrafitto

Sgraffito involves scratching out colour to create lines or texture. Any tool can be used, even a finger nail, although painting or palette knives, or the end of a brush are frequently employed.

imprinting

Karel Schmidtmayer made impressions in his painting to add texture. All kinds of objects can be used in this way to create interest, either pressing the objects into the paint, or drawing an implement across the surface. The effects achieved are dependent on the thickness of the paint and the amount of pressure exerted.

scumbling

If a lightly loaded brush (or knife) is drawn over the surface of another dry layer of paint, it will adhere to the texture of the surface below. This can be useful to create textures such as stone or distressed wood in the same way as glazing over an impasto surface. Scumbling can also be useful for modifying colours that seem too insistent. By dragging another colour over the top, be it light over dark, or dark over light, the strident colour can be softened. The broken colour creates a dynamic surface, and the process can be repeated many times, considerably enlivening an image.

dry brush work

Texture can also be achieved by using a dry brush lightly loaded with paint. As in scumbling, the texture of the underlying surface will be picked up producing a broken colour.

alla prima

To paint 'alla prima' is to complete a painting in one session. This approach involves no initial under-painting, except perhaps a foundation drawing in charcoal or pencil. The artist needs to keep his or her eye on the entire painting throughout, balancing colour, tone, volume, etc., and thus needs to have confidence. Working wet on wet, the method doesn't allow for very much modification, since if it is overworked the paint will lose its freshness. Those who choose to work in this way tend to paint freely and spontaneously.

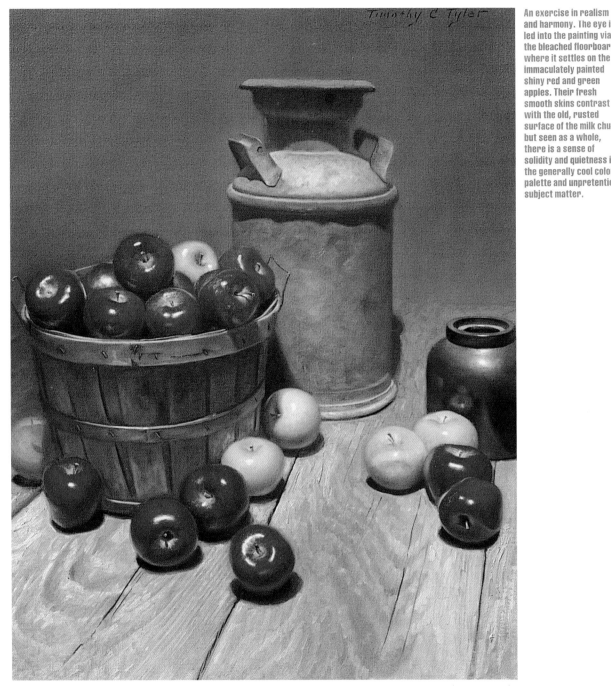

An exercise in realism and harmony. The eye is led into the painting via the bleached floorboards where it settles on the immaculately painted shiny red and green apples. Their fresh smooth skins contrast with the old, rusted surface of the milk churn but seen as a whole, there is a sense of solidity and quietness in the generally cool colour palette and unpretentious subject matter.

Delicious Harvest
by Timothy Tyler

Enriquillo Rodríguez Amiama

Florence Terry 9,
Torre Don Alfonso I, Naco,
Santo Domingo, Dominican Republic
telephone: +00 1 (809) 540 3173
email: enriquillo@amiama.com
website: www.amiama.com

Darren Baker

14 Victoria Road, Saltaire,
West Yorkshire, BD18 3LQ, UK
telephone: +44 (0) 1274 580 129
email: admin@dbfinearts.com
website: www.dbfinearts.com

Juana Cañas

email: jc@almadreams.com
website: www.still-lifes.com

Judith Carter

64 Radford Road, Leamington Spa,
Warwickshire, CV31 1JG, UK
telephone: +44 (0) 1926 314 102

Jonathan Chapman

5 Harrow Lane, Daventry,
Northamptonshire, NN11 5GW, UK
telephone: +44 (0) 1327 301 960

Kristine A. Diehl

10530 West Riverview Drive,
Eden Prairie, MN 55347-4921, USA
email: art@kdiehl.com
website: www.kdiehl.com
Kristine can also be contacted
through: Meadow Creek Galleries,
3600 Galleria, Edina, MN 55435, USA
telephone: +1 (952) 920 7123
fax: +1 (952) 920 7522
email: meadowcreek@bigplanet.com
website: www.meadowcreek.com

Arthur Easton

Whippets, 30 Underhill Crescent,
Lympstone, Devon, EX8 5JF, UK

Peter Graham

Flat 1, 'The Knowe', 301 Albert Drive,
Pollokshields, Glasgow, G41 5RP, UK
telephone and fax: +44 (0) 141 423 5081

Martha Hayden

PO Box 20647, New York, NY 10009, USA
telephone: +1 (212) 673 3841
email: martart@aol.com
website: www.marthahayden.com

Vladimir Ilibayev

Stabu Str 46/48 – 34, Riga,
LV-1011, Latvia

mobile telephone: +00 (371) 9 559 121
email: artcity@parks.lv *and*
artcity@artcity.lv
website: www.artcity.lv

Kathryn Massey

Massey Fine Art,
9390 Spring Mill Road, Indianapolis,
Indiana, 46260, USA
telephone and fax: +1 (317) 566 8709
email: artist@masseyfineart.com
website: www.masseyfineart.com

Anna Metelyova

Bazhova Street, 133, 44,
Yekaterinburg, Ural, Russia
telephone: +00 (7) 3432 24 41 46
email: anna@artshow.ru
website: www.artshow.ru

Rita Monaco

468 East 28 Avenue, Vancouver,
British Columbia, V5V 2N3, Canada
telephone and fax: +00 1 (604) 876 0059
email: bogart@radiant.net
website: www.ritamonacostudio.com

Roberta Morgan

HC 62, Box 109P, Great Cacapon,
West Virginia 25422-9719, USA
telephone: +1 (304) 947 7242
email: rmart@citlink.net
website: www.citlink.net/~rmart

Teresa Pemberton

15 Oxhey Road, Watford,
Hertfordshire, WD19 4QF, UK
telephone: +44 (0) 1923 250721
email: teresa@pembertonarts
.demon.co.uk
website: www.teresapemberton.com

Hilary Pollock

25 Nagle Avenue, Springwood 2777,
Australia
email: hilarypollock@dingoblue.net.au
website: www.hilarypollock.com.au

Doug Rugh

604 County Road, Pocasset,
MA 02559-1976, USA
telephone and fax: +1 (508) 759 6910
email: doug@dougrugh.com
website: www.dougrugh.com

Rafael Saldarriaga

22 Leroy Street, Suite 6, New York,
NY 10014, USA
telephone: +1 (212) 727 8744
email: saldarria@aol.com
website: www.rafaelsaldrriaga.com

Karel Schmidtmayer

Svatopluka Cecha 399, 37881
Slavonice, Czech Republic
telephone: +00 (420) 332 493718
email: jarka@dacice-info.cz
website: www.karelschmidtmayer.
artistportfolio.co.uk/gallery.htm

Philip Sutton

3 Morfa Terrace, Manorbier, Tenby,
Pembrokeshire SA70 7TH, Wales, UK
telephone: +44 (0) 1834 871 474

Robert Talbot

25 Collingwood Road, Earlsdon,
Coventry, CV5 6HW, UK
telephone: +44 (0) 2476 67855
email: rtalbot@ntlworld.com

Timothy Tyler

PO Box 5142, Bella Vista,
AR 72714, USA
telephone: +1 (417) 475 7157
email: artanion@cox-internet.com
website: www.timothyctylerfineart.
homestead.com

Richard Wieth

PO Box 564, Black Hawk,
CO 80422-0564, USA
telephone and fax: +1 (303) 582 3425
email: wieth@worldnet.att.net
website: www.home.att.net/~wieth/

Writing a book is a great pleasure, made all the more enjoyable by the supportive and professional team behind me. Many thanks are due to Kate Stephens, my editor, for guiding me through the production process; Sally Chapman-Walker for her excellent design; Robin Wiggins for so competently providing the various paint effects and palettes; and Julien Busselle for his superb photography.

Huge thanks are due, of course, to all of the wonderful artists who have contributed their time and work so generously to the project. They have been a joy to work with and I have very much appreciated their warmth and openness throughout the development of the book.

Final thanks must go to my family – my parents for their unconditional support that has enabled me to juggle my roles, and to Freddie and Raphaella, my lovely, long-suffering children. This book is dedicated to them.

6/26/04